OODLES OF Doodles

2nd Edition

ISBN 978-1-4972-0413-3

© 2018 by Suzanne McNeill and New Design Originals Corporation, *www.d-originals.com*, an imprint of Fox Chapel Publishing, 800-457-9112, 903 Square Street, Mount Joy, PA 17552.

Oodles of Doodles, 2nd Edition is a collection of new and previously published material. Portions of this book have been reproduced from *Oodles of Doodles* (978-1-57421-615-8), *Dots 'n Doodles* (978-1-57421-743-8), *Gel Pen Doodles* (978-1-57421-430-7), and *Letter Better* (978-1-57421-741-4).

We are always looking for talented authors. To submit an idea, please send a brief inquiry to acquisitions@foxchapelpublishing.com.

Printed in Singapore
First printing

Shutterstock photo credits: Katerina Davidenko (4 background, 5 leaf upper right corner, 62); LanaN (5 frame left, 125); Natasha Pankina (5 fireworks left center, 68, 93); Mallinka1 (6 vines top and bottom, 8 vines right and left, 27, back cover third framed picture from the left); 9george (7 blue stars and yellow flowers, 88, 92, 105); Macrovector (8–9 background image); mhatzapa (8 various doodles in background image, 24 gears right of heading, 63, 73, 81, 139, 152 doodles to the right and left of heading in box); ddok (10 background); Viki Green (24 globe left of heading, 65, 160 bottom right doodles); A.I. (28); SunshineVector (29); graphic stocker (31, back cover upper right flowers and vine on right border of box); Emila (32); Virinaflora (50 background image, 55); Franzi (57); Tiwat K (66, 84, 85, 89); redchocolate (69); dizdino (70); primiaou (71, 99, 103); AuraArt (72); topform (74); balabolka (75); Olga Zakharova (80); Crystal Eye Studio (86–87); Marina Mandarina (91); Cat_arch_angel (94, 152–153 background); Padma Sanjaya (96); balabolka (97); Fafarumba (100); Erica Truex (101); VOOK (122); AKaiser (123); Natalia Sheinkin (124 background image, 137); Amma Shams (136); Danussa (138); halimqd (140); Icons vector (141); and blue67design (144).

OODLES OF Doodles

CREATIVE DOODLING & LETTERING FOR JOURNALING, CRAFTING & RELAXATION

2nd Edition
Suzanne McNeill

DESIGN ORIGINALS
an Imprint of Fox Chapel Publishing
www.d-originals.com

CONTENTS

Introduction: Why Doodle? 6

GETTING STARTED 8
Materials...10
Techniques..14

DOODLES24
Nature...26
People, Places & Things50
Abstract...76
Seasons & Holidays.......................88
Letters & Numbers......................106
Borders & Frames124
Word Art ..142

PROJECTS152

About the Contributors.............160

ABC
45

Introduction: Why Doodle?

You have most likely already been doodling for years. (Remember your school notebooks?) But as it turns out, it's not an impulse you should suppress. This seemingly mindless activity has a ton of benefits:

- **Doodling can help you focus.** Seriously! Studies have shown that it can help keep you in the moment, and that you'll remember more of what was going on while you doodled. So go ahead and doodle on your notes during your next boring class or meeting. You might just end up a better student or employee.

- **Doodling relieves stress.** And after all, it's just a doodle; there's no pressure to make it perfect.

- **Doodling leads to new ideas.** Creativity leads to more creativity. You never know what connections you might make as you draw them out.

- **Doodling can help improve your drawing skills.** Your piano teacher was right: practice, practice, practice.

How to Use This Book

Your doodles don't need to be museum quality; the act is more important than the outcome. But sometimes it's hard to interpret a three-dimensional object in two dimensions. This collection is here for your practice and inspiration. First, find something that resonates with you. (Hearts? Page 78. Nature? Pages 26–49. Food? Same here! Page 69–71.) Then grab a notebook and something to write with. The doodles in this book were done with pencils, pens, gel pens, paint pens, markers, and more; whatever you have on hand is fine. Then go for it: put pen to paper and draw your doodle. Draw it a few times. What does it look like if you add more details to it? What does it look like if you draw it with a different medium? What if you add texture or change the colors?

How to Use These Doodles

- **Fill up your sketchbook or journal.** Give yourself the space you need for brainstorming, reflecting, unwinding, and simply playing.

- **Illustrate your planner.** Motivate yourself with all manner of banners (page 139), arrows (pages 79–81), and doodles of your goals, whether they're fitness-related (page 66), financial (page 85), or anything else.

- **Decorate the margins.** Doodling during the meeting or phone call can actually help you pay attention, and who knows! It may also inspire your next big idea.

- **Personalize gifts and letters.** We don't handwrite much these days, so when you do, make it special. Use a doodle alphabet (pages 106–122) to write your friend's name, add a border (pages 126–134) to the note you leave on your coworker's desk, or cover the outside of a gift card envelope with doodles of what it will buy.

- **Craft away.** These doodles don't just work on paper. You can use them on whatever craft projects you're busy with, from mason jars to wooden signs to scrapbooking and card making.

- **And be creative!** Doodle here, there, and everywhere you can fit a handmade moment into your life.

GETTING STARTED

Beginning your doodling habit starts with finding the right materials. Your eyes may widen at the many choices to consider as you stare down a wall of pens and markers at the store. Do you go with a fine tip pen or one with a brush tip? Colorful or black? And who knew that there were so many different types of ink? It can be more than a little daunting. The best way to discover your favorite doodling supplies is to experiment as much as possible. Doodling is all about personal preferences, so what works for someone else might not necessarily work for you. Try out different brands and styles of pens and markers. If you're still unsure of where to start, this section has you covered.

You'll also learn how to get started putting pen to paper. Just like almost anything in life, doodling gets easier with practice. You may find it difficult to know what to draw when you begin, but you'll find your ideas and creativity have an easier time flowing the more you doodle. This section will go over some basic techniques you can immediately apply to your doodling.

Materials

There are so many pens on the market that it can be overwhelming to choose just the right one to use. But in the end, all pens work well for doodling. Here are a few tips that might help you decide:

- For journals and scrapbooks, you'll want the ink to last for a long time. Look for the words *archival* and *lightfast*. *Permanent* means the ink won't run when touched by water. When in doubt, check the manufacturer's website.

- For long freehand scroll marks, a brush tip will give you a lovely varied line quality.

- For finer lines, a finer tip—0.3mm, 0.5mm, or 0.7mm—will work well. The 0.5mm is the most versatile for general use.

- For dots, try a bullet nib. Just press for an instant large dot. Fast and easy!

- Permanent ink and India ink typically work well if you need to write directly on photos.

- Don't forget to store your pens horizontally to help keep the ink from drying out!

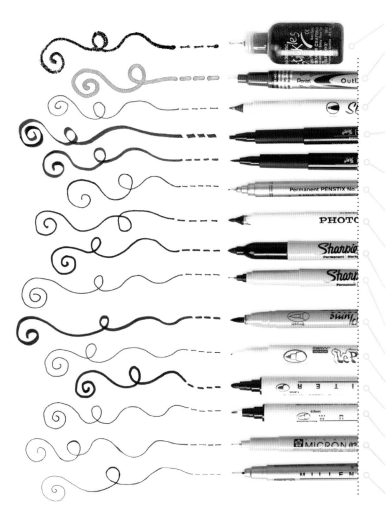

Ranger Stickles™ Black

Pentel® Outline™ Marker

American Crafts™ Slick Writer Fine Point

Faber-Castell® PITT® Calligraphy Tip

Faber-Castell® PITT® Small Brush Tip

Alvin Penstix 0.3mm

American Crafts™ Photo Marker

Sharpie® Fine Point (Bullet Tip)

Sharpie® Ultra Fine Point

Marvy® LePlume Brush Tip

Marvy® LePlume Fine Tip

ZIG® Writer 1.2mm Bullet Tip

ZIG ® Writer 0.5mm

Sakura® Pigma® Micron® 03

ZIG® Millennium 01™

Tips for Using Paint Pens on Non-Paper Items

- Wash and dry the object you'll be painting on thoroughly.

- Holding both ends of the paint pen, shake it before use.

- Gently depress the point on a piece of scrap paper for 60 to 90 seconds to saturate with paint. Repeat as needed during use. Keep tightly capped when not in use.

- Clean up smudges with a cotton swab soaked in mineral spirits.

- Check the manufacturer's instructions, but this paint usually dries in 3 minutes and is scratch resistant in 6 hours.

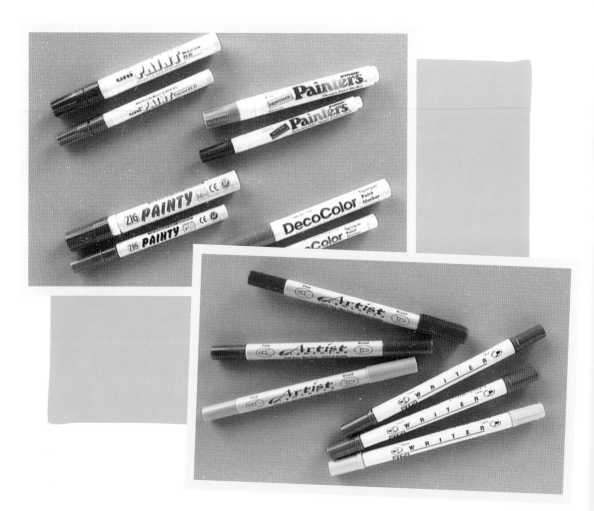

Tips for Using Gel Pens

- Experiment with several different pens to find the ones you like best.

- Gel pens write best on paper and somewhat porous surfaces.

- Gel pens will smear on slick or glossy surfaces, such as a vinyl notebook or leather sneakers.

- Gel pens can be embossed with an embossing heat tool, even on glossy paper! Try it with clear embossing paper; it makes a fun effect.

- The metallic inks take a few minutes to dry. Be careful not to smear them.

- Gel pens are not meant to be permanent on clothing. For items such as hats and shoes, you can spray a coat of Scotchguard™ to protect the design. However, the design will fade if washed.

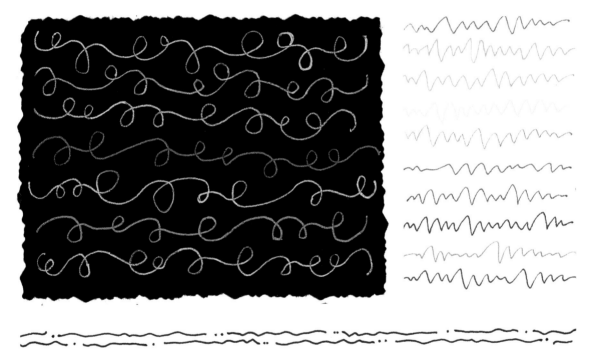

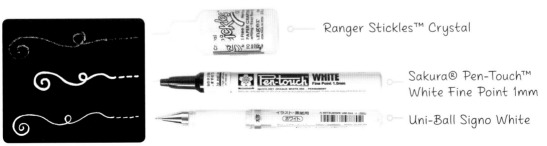

Ranger Stickles™ Crystal

Sakura® Pen-Touch™ White Fine Point 1mm

Uni-Ball Signo White

Techniques

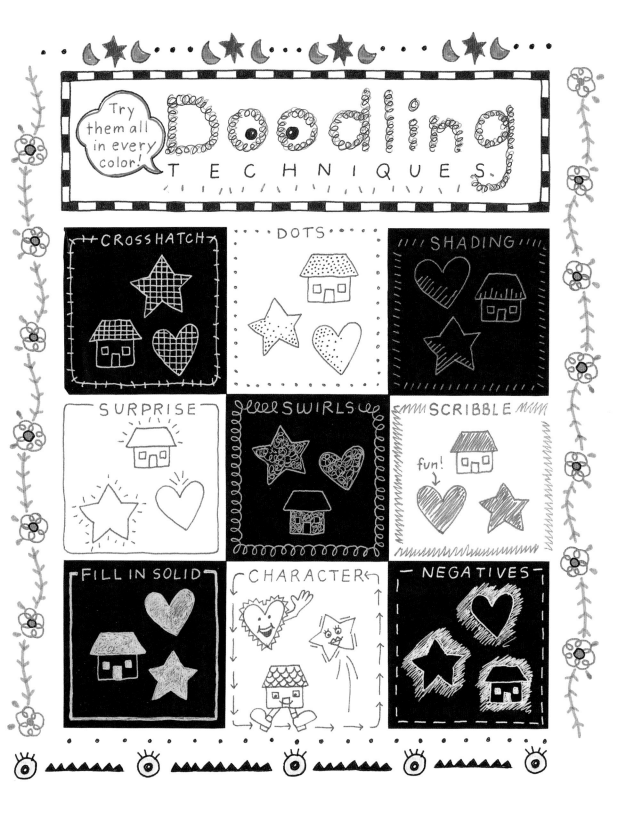

Freehand Doodling

If you are one of the many people who want to doodle but hesitate when your pen nears the page, this lesson was designed for you.

First, know there are no mistakes. Turn an ink blob into a filled-in circle or a stray mark into an ornate swirl or dotted pattern. The examples below will get you started.

Need more ideas? Have you ever noticed the design on expensive ironworks or looked at motifs carved on buildings? Take a look at the patterns in your kitchen floor tile. Many of these simple designs can be easily reproduced in doodles.

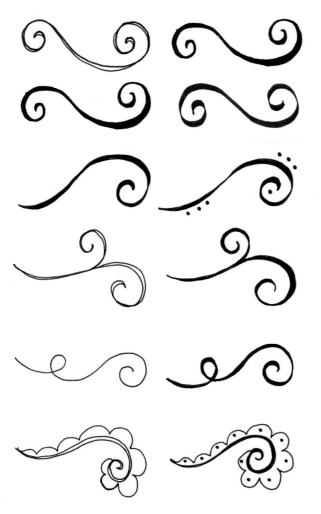

Begin by lightly drawing a simple swirl with a pencil. Then trace over it with a marker.

Draw flowing curves first. Then enhance the design with dots.

Draw the simple swirl. Then add a shadow. Use a pen to trace and fill in the thicker areas.

Loops and curls are easy. Draw them with a pencil first; you can erase them if you want to change how they're flowing.

Accent the outside curve of a swirl with a scallop. Add dots for a lacy look.

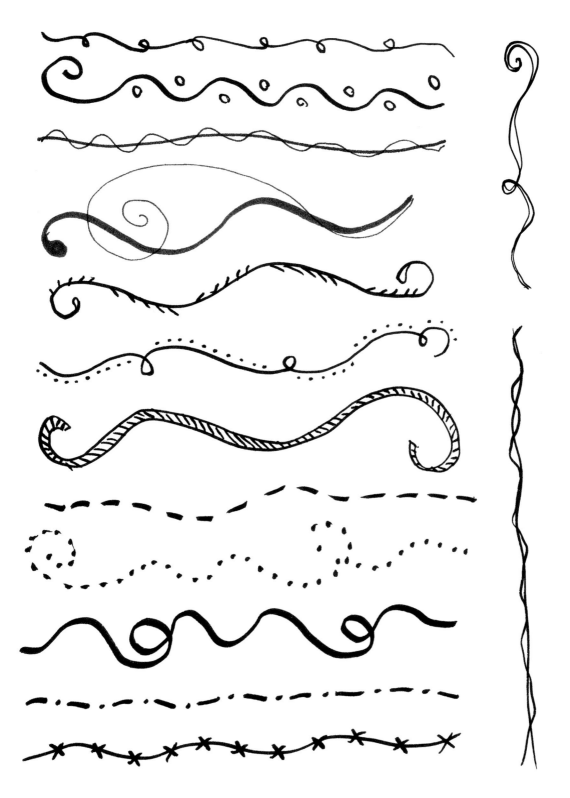

Dots & Dashes

1. Begin with large dots and use them as a guideline. These smaller dots are too close together.

2. Here the dots are evenly spaced but too far apart.

3. Here dots are spaced evenly and the letter is easy to read. To place small dots in a row, rest your hand on the table as you make the dots and bounce the pen in a row. If the ink stops flowing, push the pen tip down on scrap paper to re-ink the tip and then continue.

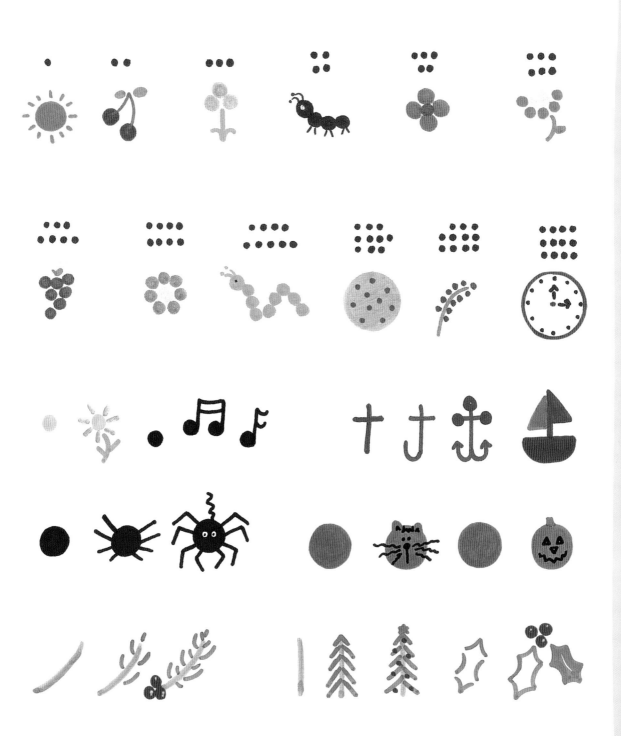

Straight Lines & Swirls

Always work from top to bottom and left to right to prevent dragging your hand through a design you have just drawn.

> Use a ruler or place masking tape as a guide to make straight lines a breeze. For really straight borders, evenly space out two strips of masking tape and draw the border between the strips.

Teardrops

Draw the outline of the teardrop and fill it in.
When making a larger heart, draw the heart then draw a teardrop highlight. Color around the highlight. You can add a highlight later with white, but be sure the first color is completely dry.

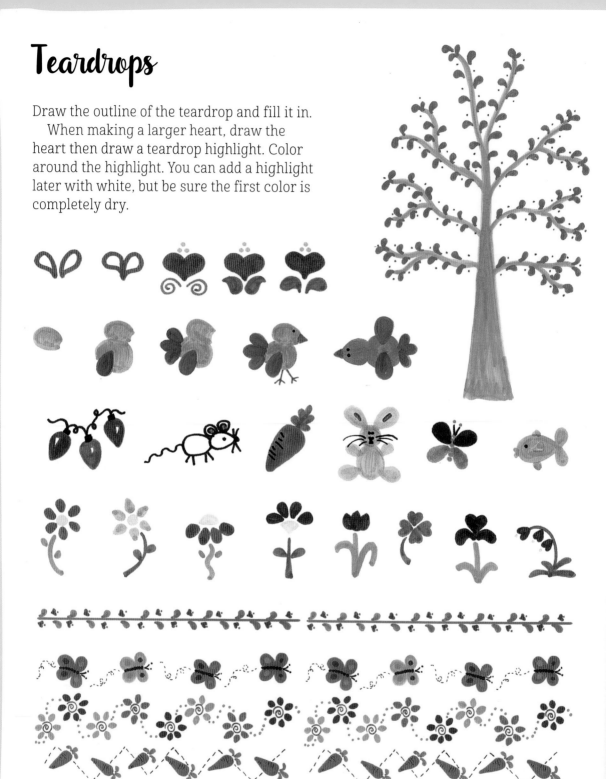

Blobs, Blocks & Shapes

Combine the other shapes you've practiced with blobs and blocks to make all kinds of shapes.

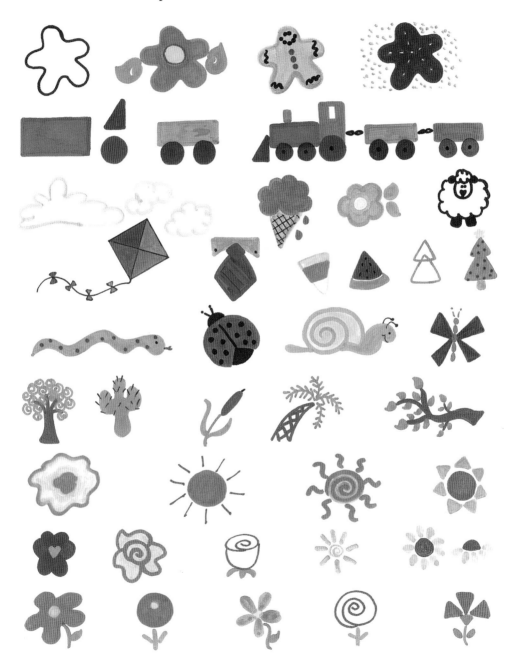

DOODLES

Now the fun begins! Pick up your chosen writing materials, and let your creativity flow. There are *a lot* of great doodles in this section that will definitely inspire you. Take the time to skim through all of the illustrations and try your hand at drawing the first doodle that appeals to you. It's okay if it doesn't look exactly like the picture. Remember, doodling isn't about perfection.

Once you've grown comfortable with your first doodles, start adding your own flair and personality to your drawings. Add color to your flower doodles, or come up with your own patterns to add to your alphabets. You'll find that the more you doodle your own style will develop over time. Keep at it, and before you know it, you'll have a sketchbook or journal full of beautiful, original designs.

Nature

What better place is there to draw inspiration from than nature? And why not? Artists have been doing just that for thousands of years. Nature is so varied that you're guaranteed to never run out of ideas. This section contains a plethora of ideas to get you started. Once you've finished with this book and have the basics down, take a sketchbook and your favorite doodling pen or marker with you outside and experience inspiration from the real deal yourself.

Lush Greenery

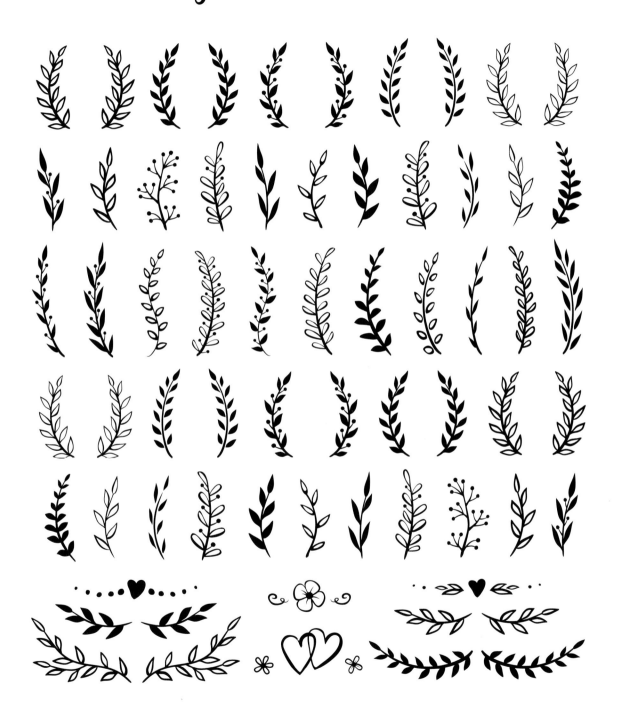

Lined Leaves

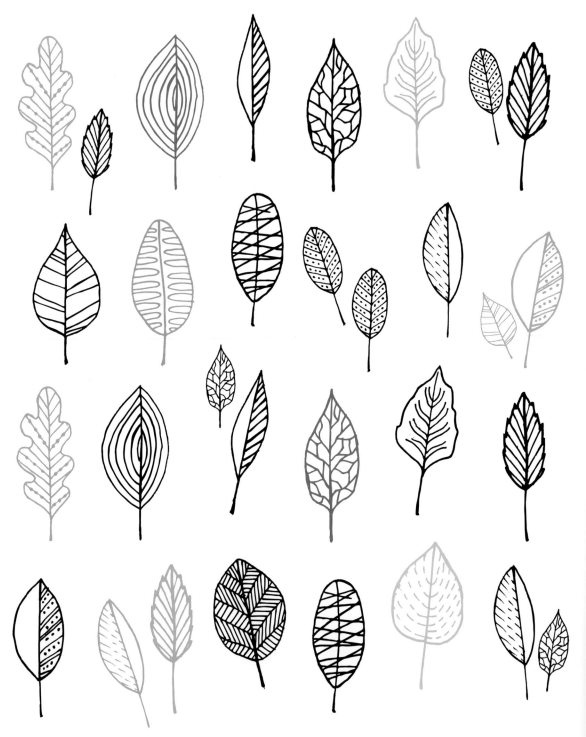

Charming Trees

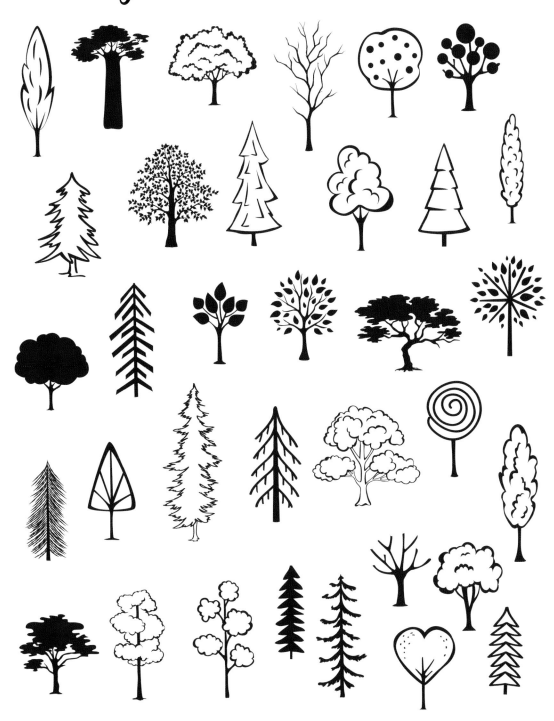

Trees & Things

Floral Spring

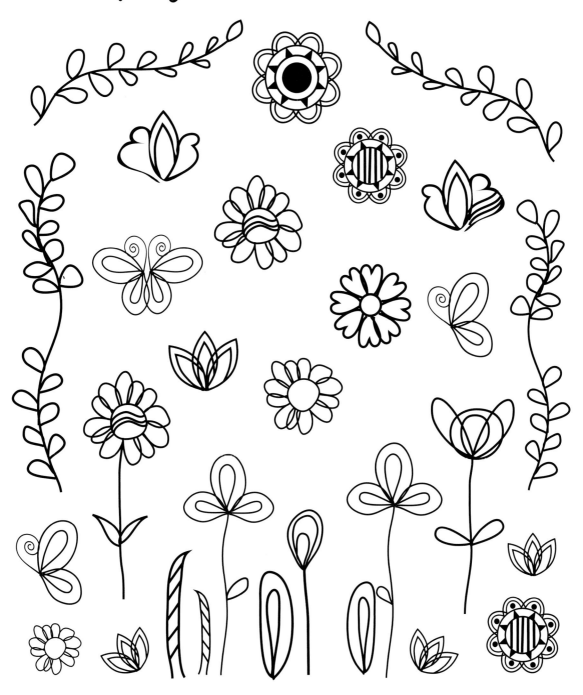

Wildflowers & Leaves

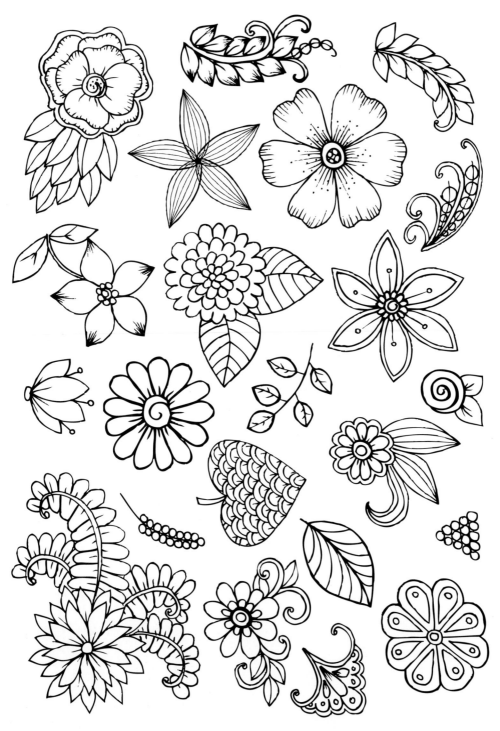

Bunches of Flowers

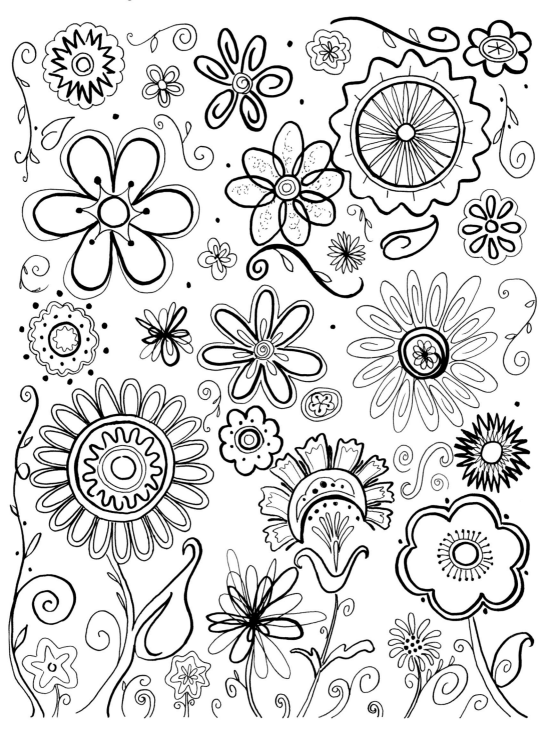

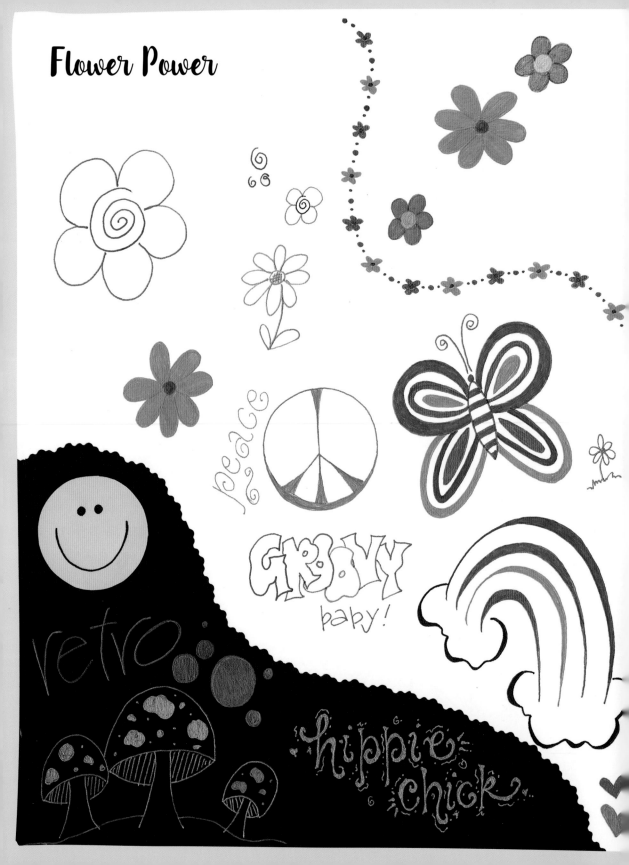

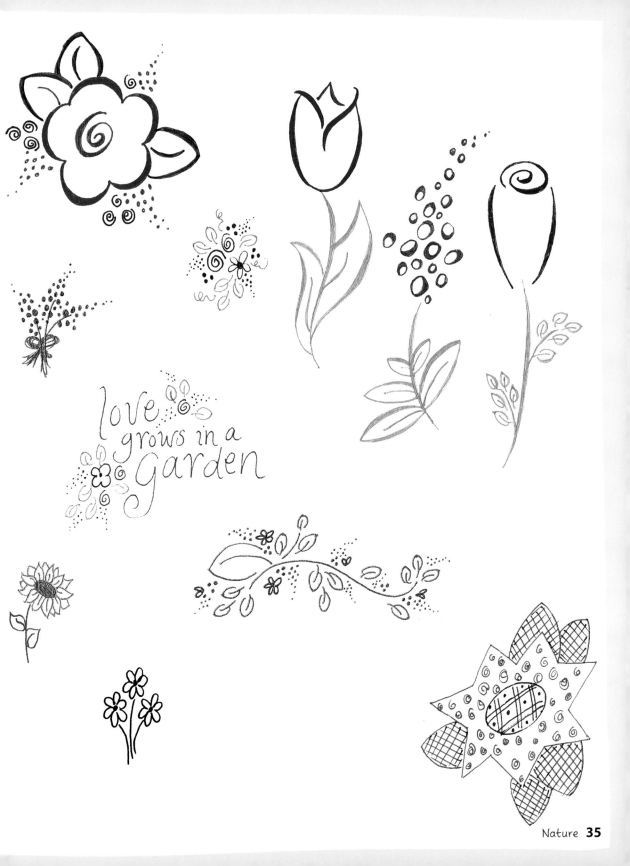

love
grows in a
Garden

Sunny Day

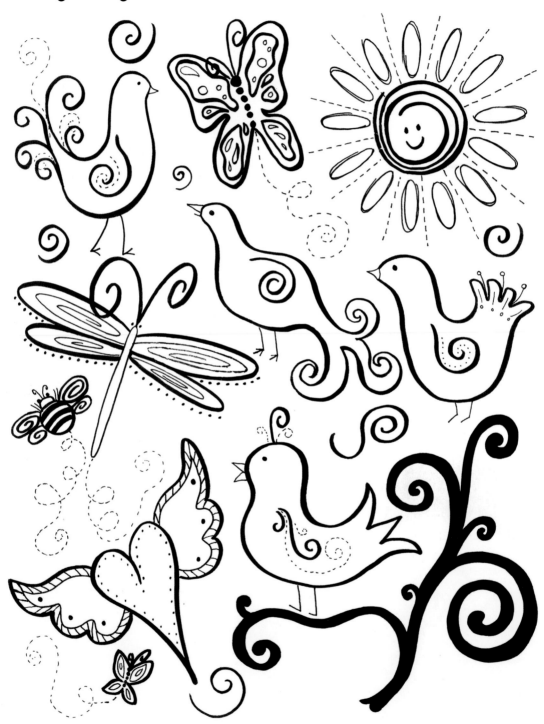

Flocks
of Birds

Animals
& Bugs

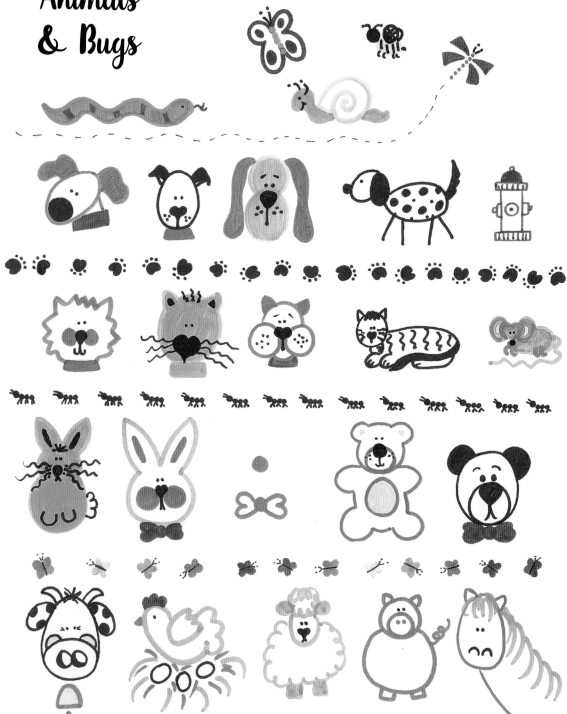

Exotic Animals

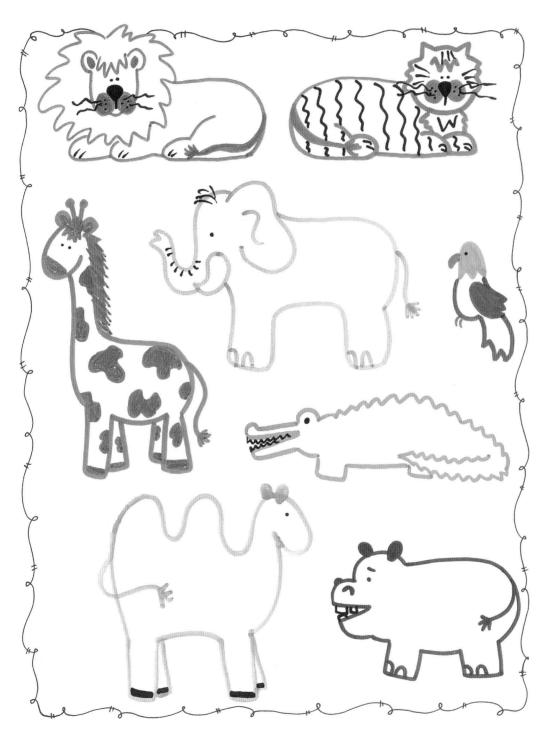

Dinosaurs

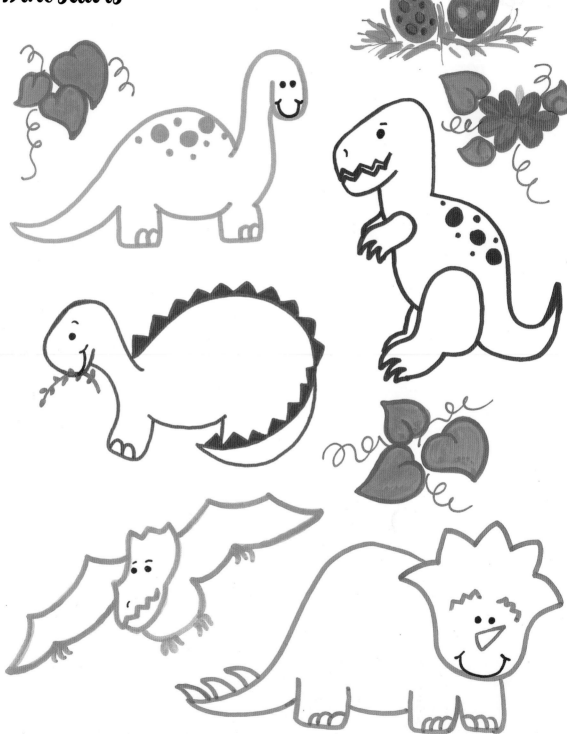

Sea Life

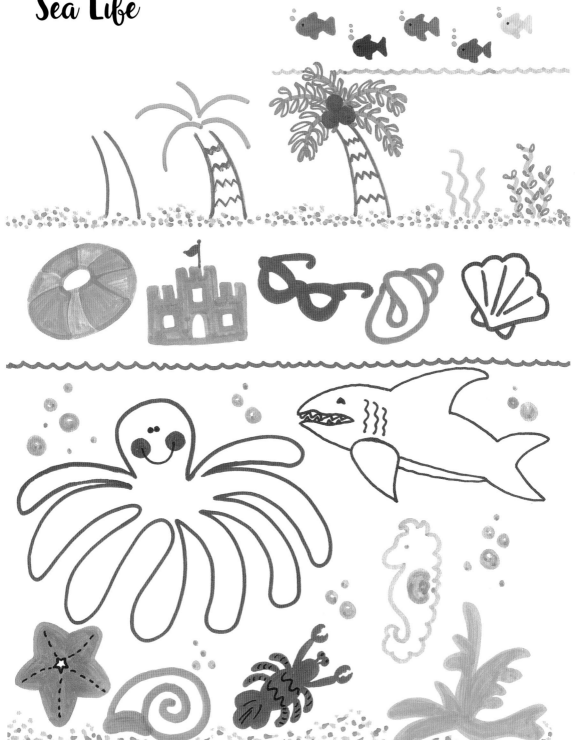

Snakes, Bugs & Lizards

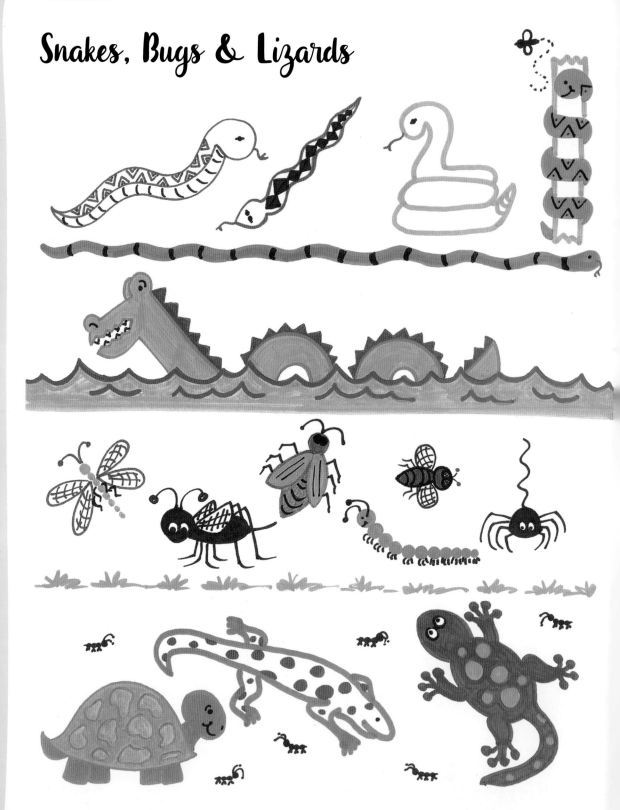

Bugs, Butterflies & Bees

if you love something, set it free...

bee happy

love bug!

I think you've got me in your web...

dragonfly

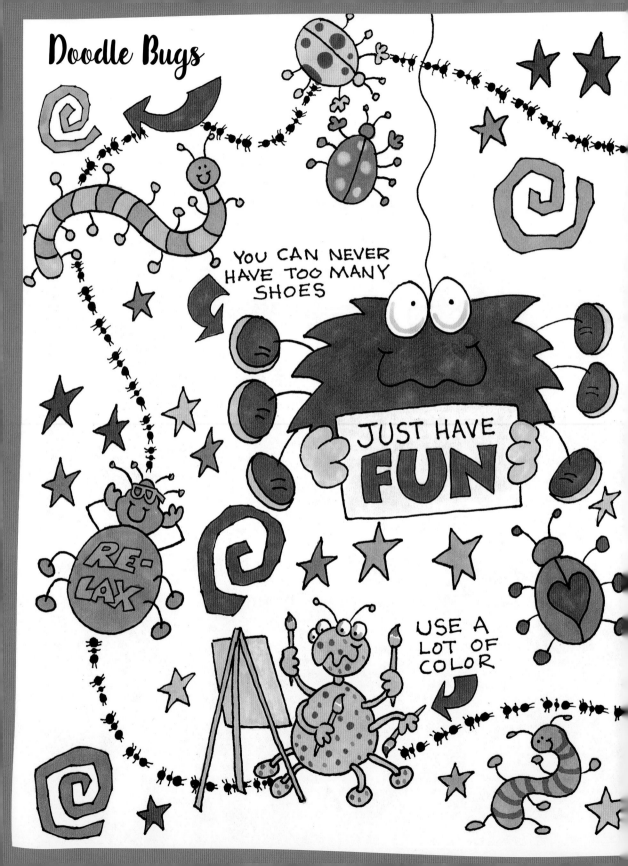

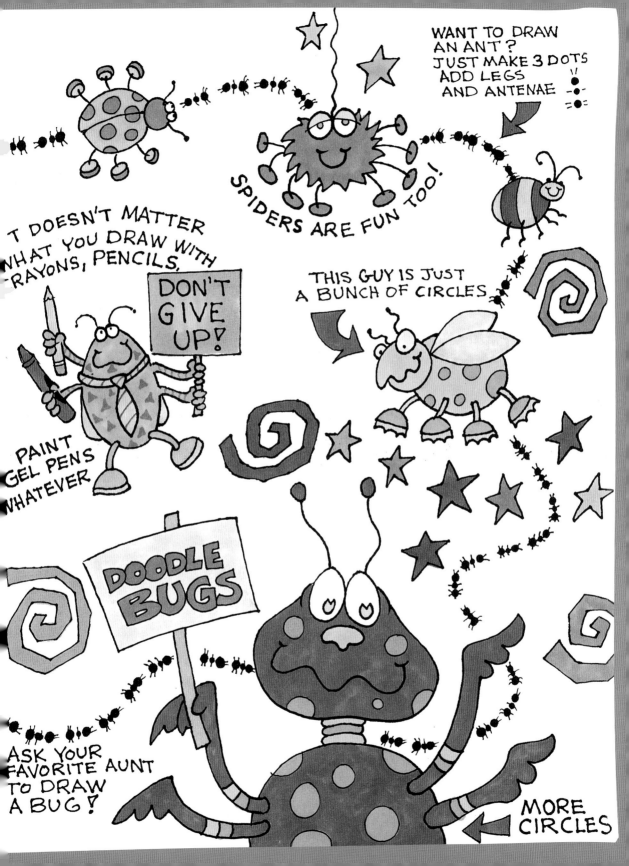

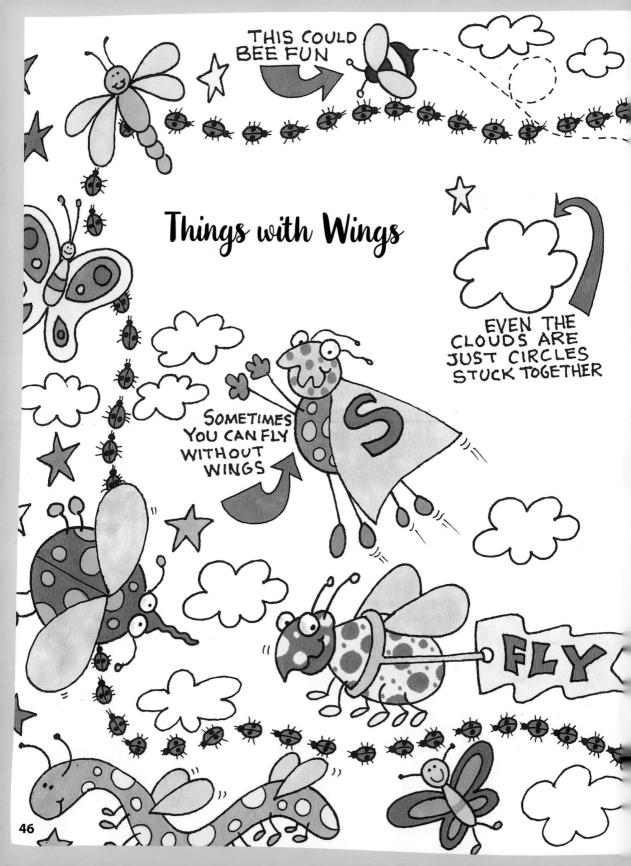

Things with Wings

THIS COULD BEE FUN

EVEN THE CLOUDS ARE JUST CIRCLES STUCK TOGETHER

SOMETIMES YOU CAN FLY WITHOUT WINGS

FLY

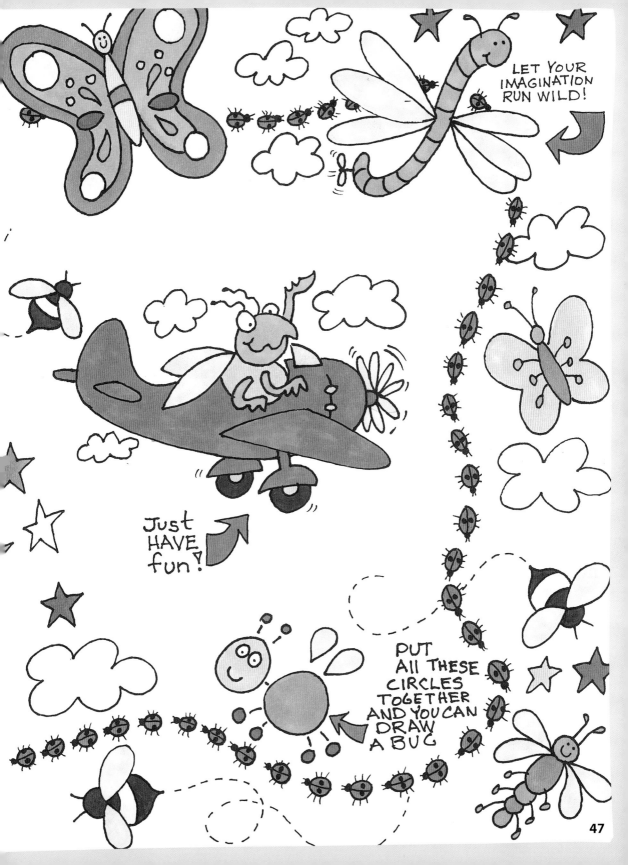

47

Cool Cats

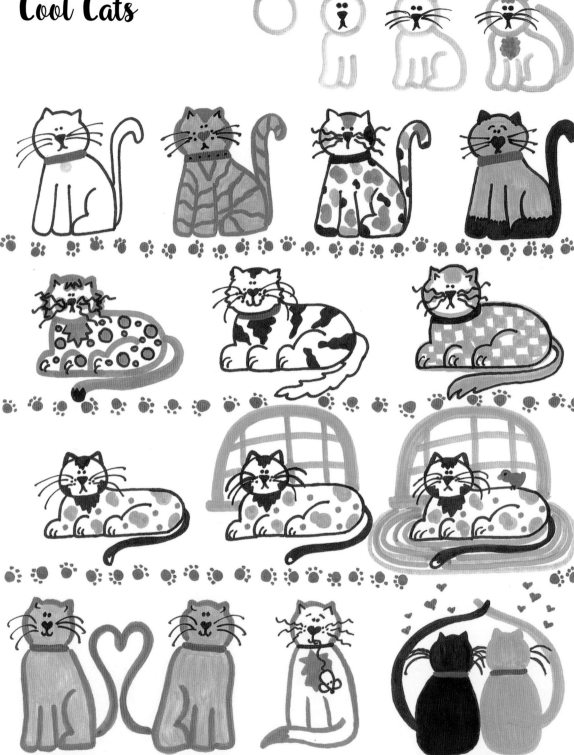

Friendly Dogs

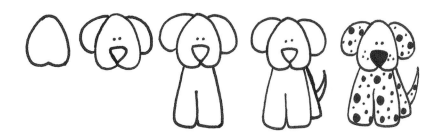

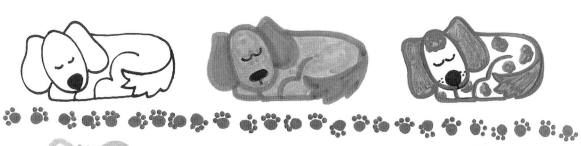

People, Places & Things

Doodling during busy times in your life will actually help you maintain your focus. Drawing inspiration from these events will not only boost your doodling prowess, but will also lower any stress you may be feeling. For example, impending nuptials always cause anxiety. If planning your wedding is making you feel more than a little frazzled, take a look at page 55 for ideas of what to doodle. The doodles in this section are also particularly useful if you're looking to boost your scrapbooking game.

Best Friends

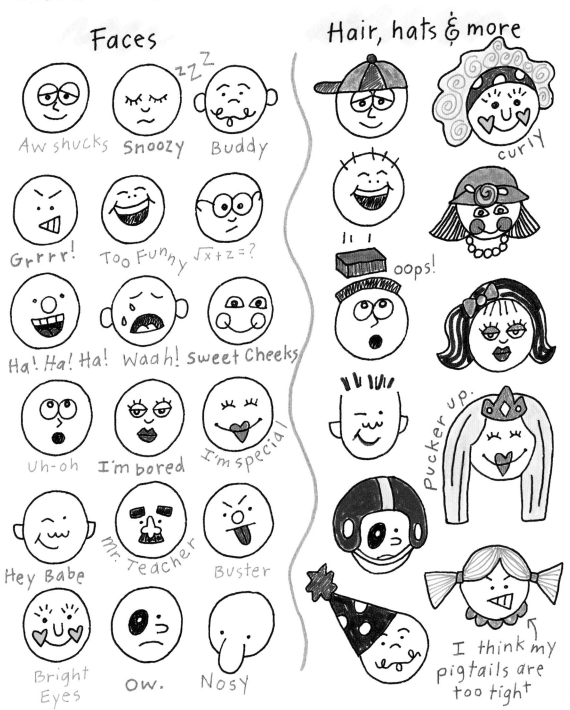

Faces

Aw shucks | Snoozy | Buddy
Grrrr! | Too Funny | $\sqrt{x} + z = ?$
Ha! Ha! Ha! | Waah! | Sweet Cheeks
Uh-oh | I'm bored | I'm special
Hey Babe | Mr. Teacher | Buster
Bright Eyes | Ow. | Nosy

Hair, hats & more

curly

oops!

Pucker up.

I think my pigtails are too tight

Faces & Figures

 Start with a circle.

 Use the letter "c" to add ears

add dots for eyes, a sideways "c" for mouth & circles for cheeks.

Skilled Athletes

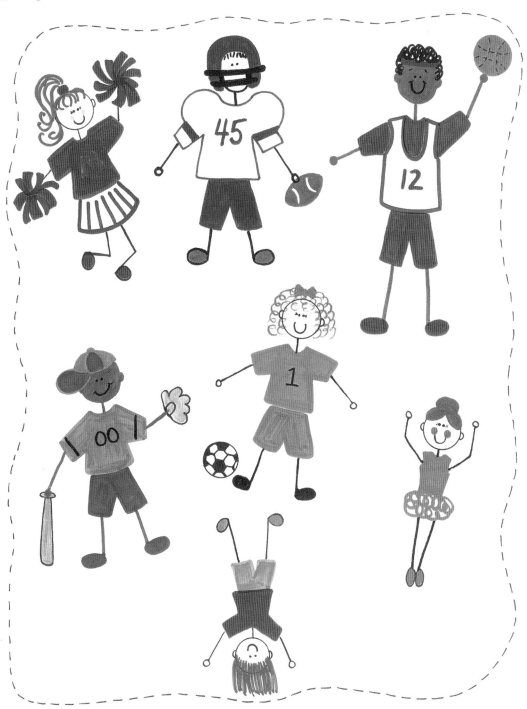

Baby Things

Wedding Bells

Most Likely to Become...

Sketchy Faces

Home Sweet Home

Farm Fun

Coming & Going

School Days

School Supplies

Business Icons

Celestial Beauty

Wish upon a Star

Star light, Star bright, first star I see tonight...

I love you to the moon and back!

reach for the Stars

what's your sign?

Astronomy

Fit & Healthy

Recreation & Sports

Basketball

NOTHIN' BUT NET

Soccer

I'm a Soccer Babe!

I got Game

softball RULES!

cheerleader

CHS

GO FIGHT WIN

tennis, anyone?

VIKINGS

You bet I hit like a GIRL!

♡ Volleyball! ...is just about my favorite thing to do! I played in high school & college, and I coach, too. I'm completely addicted to it! ♡

Volleyball

Pass, Set... CRUSH!

Kitchen Utensils

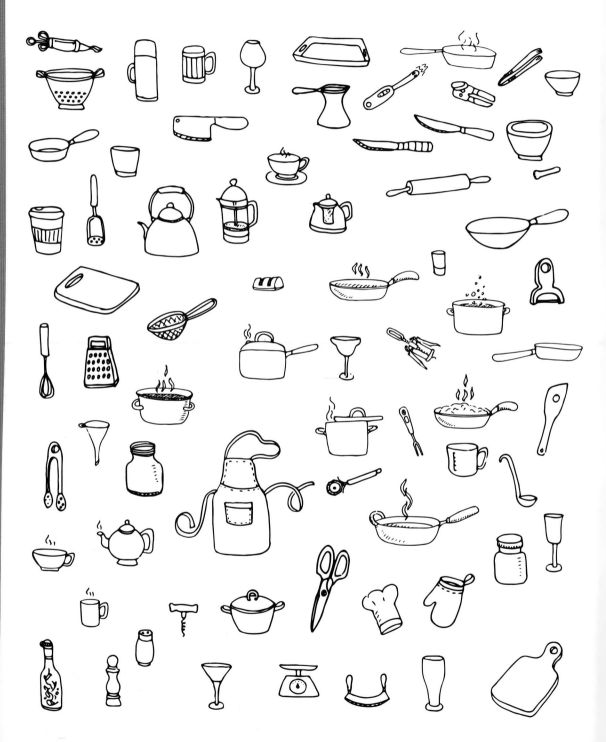

Coffee & Tea

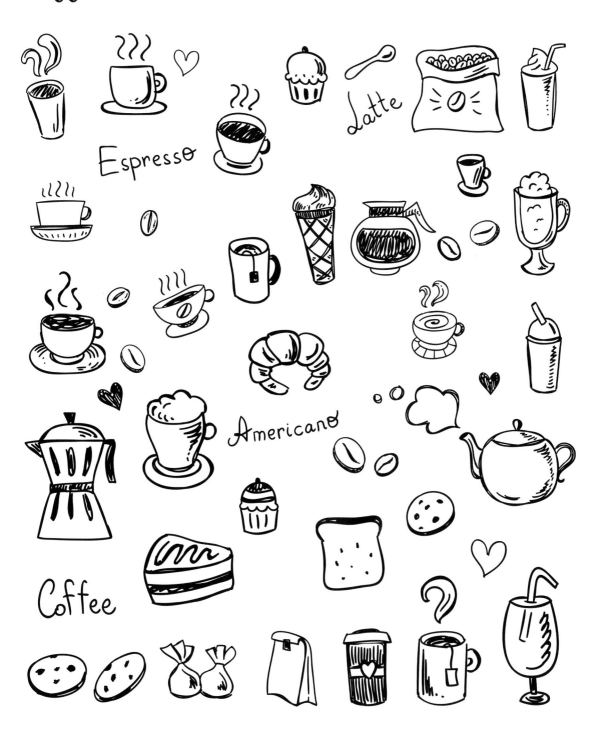

Espresso

Latte

Americano

Coffee

Fruits & Veggies

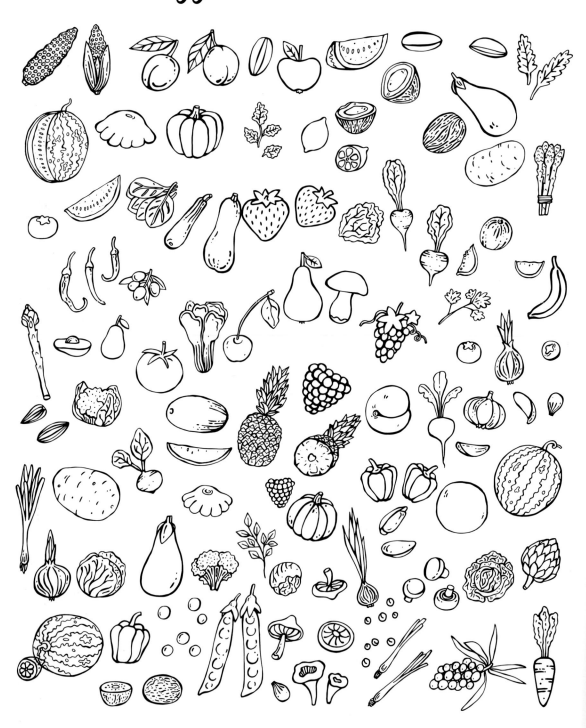

Sweet Desserts

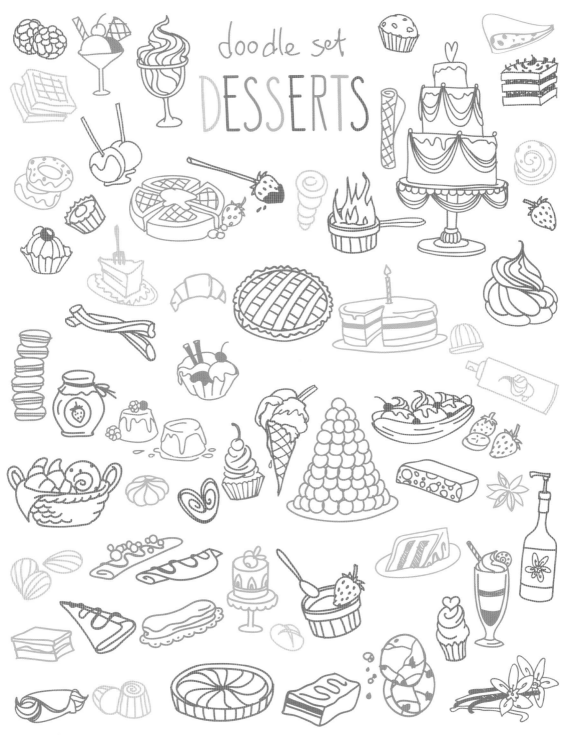

doodle set
DESSERTS

Clothing & Accessories

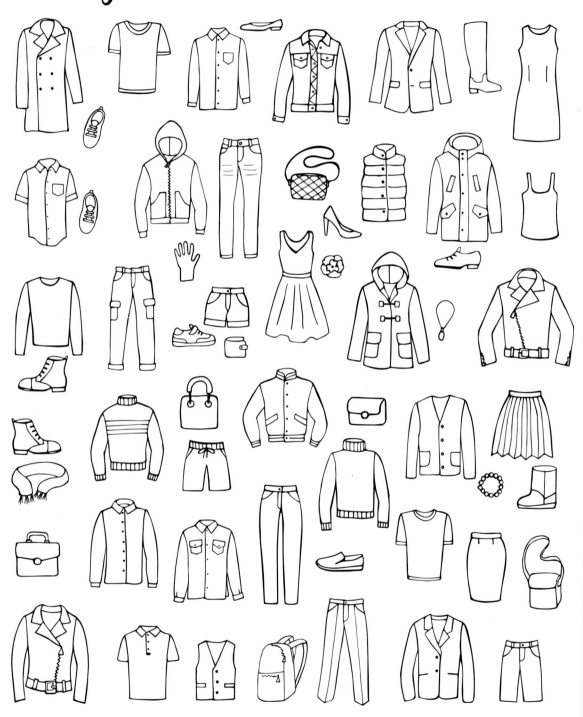

Let's Travel the World!

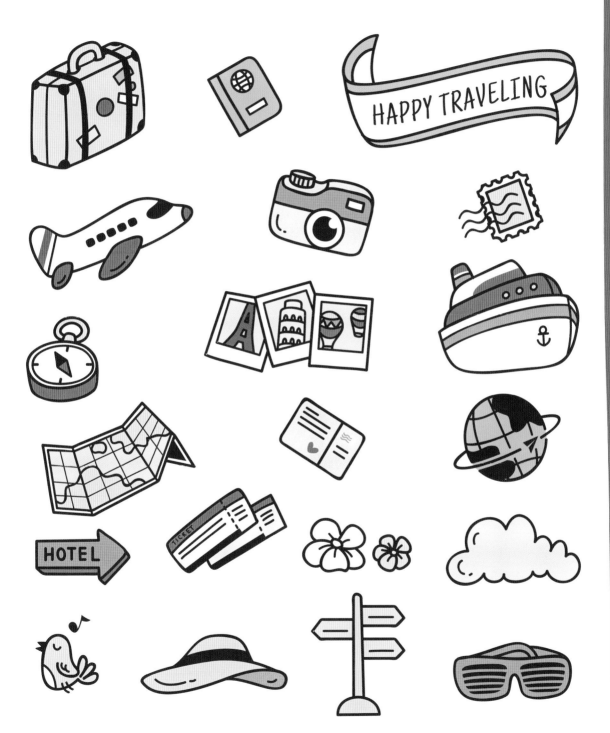

Rock On!

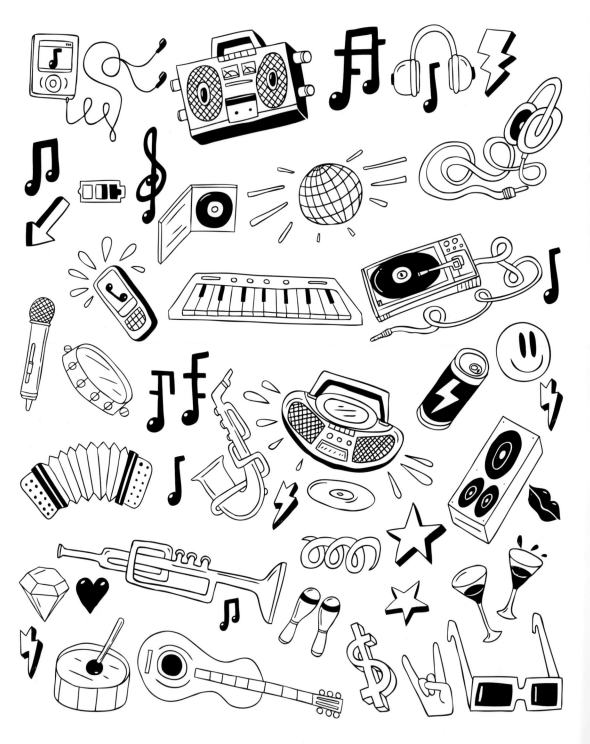

Arts & Crafts

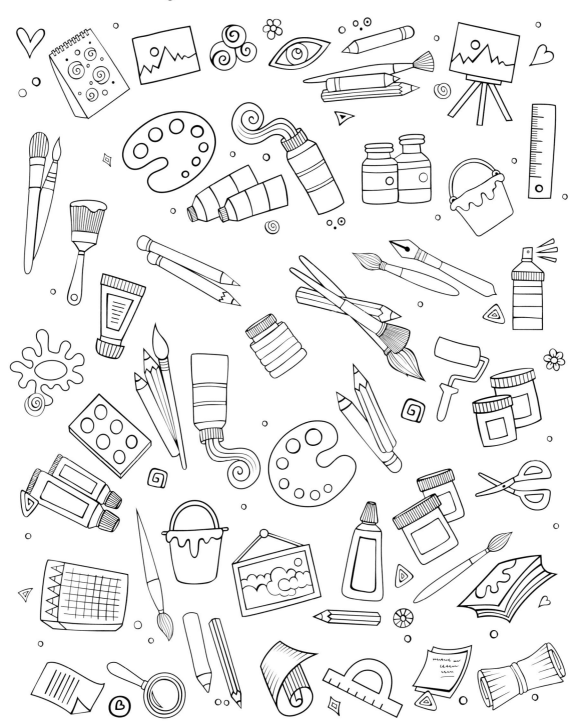

Abstract

The doodles in this section are perfect for just about anything that needs a little more pizzazz, but they are particularly perfect for journaling. Consider filling the white space in your journals with arrows, hearts, and stars. They'll add a nice touch to your pages and won't take you too much time to finish.

Curly Curves

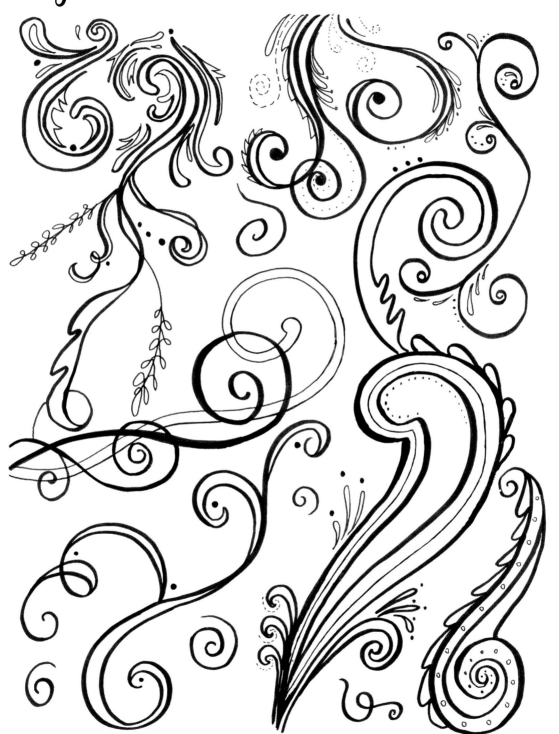

Hearts & Stars

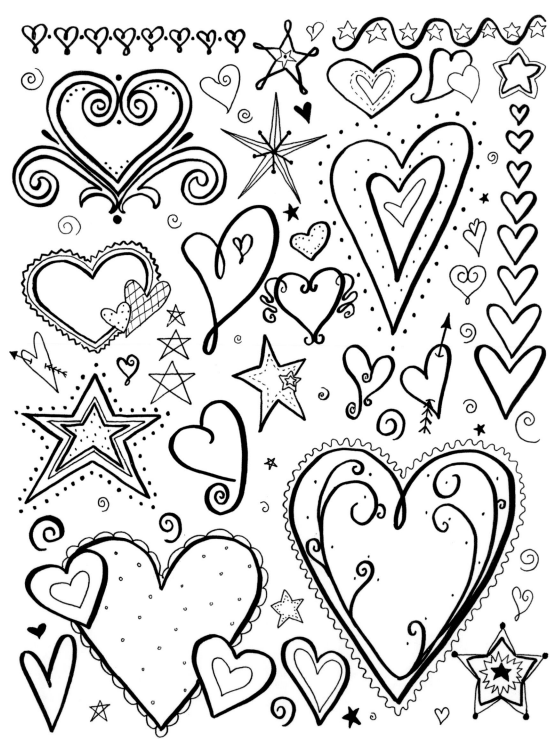

Pointed Arrows

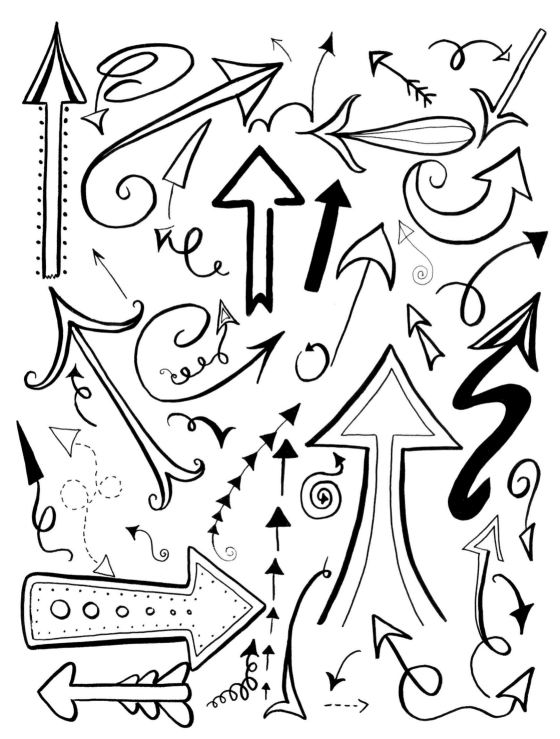

Multidirectional Arrows

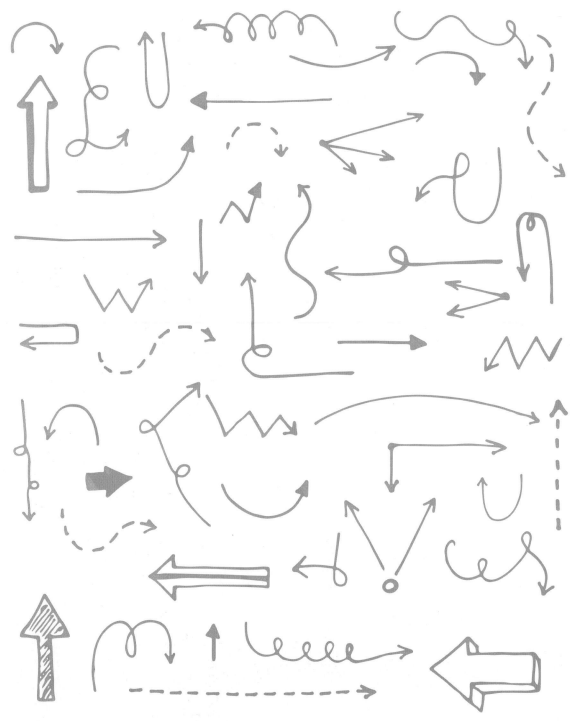

Bubble Arrows

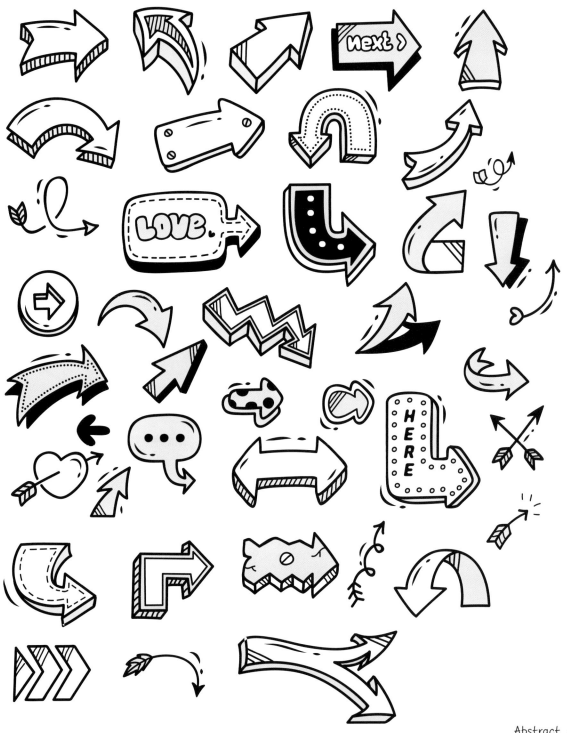

Mixed Doodles

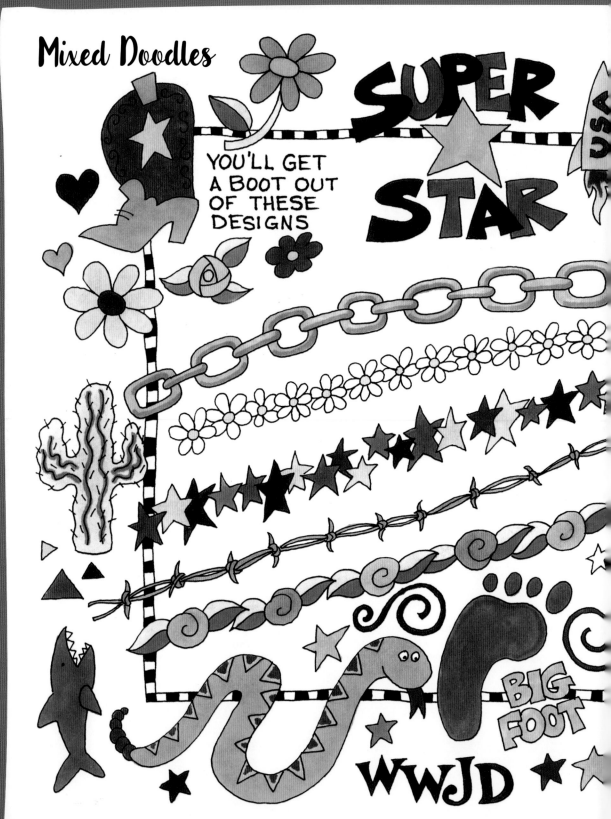

YOU'LL GET A BOOT OUT OF THESE DESIGNS

SUPER STAR

USA

BIG FOOT

WWJD

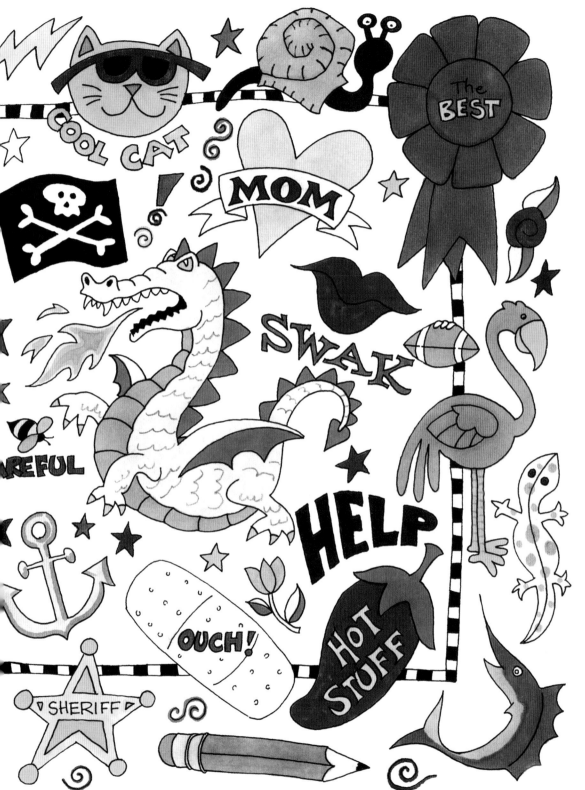

Contact Symbols

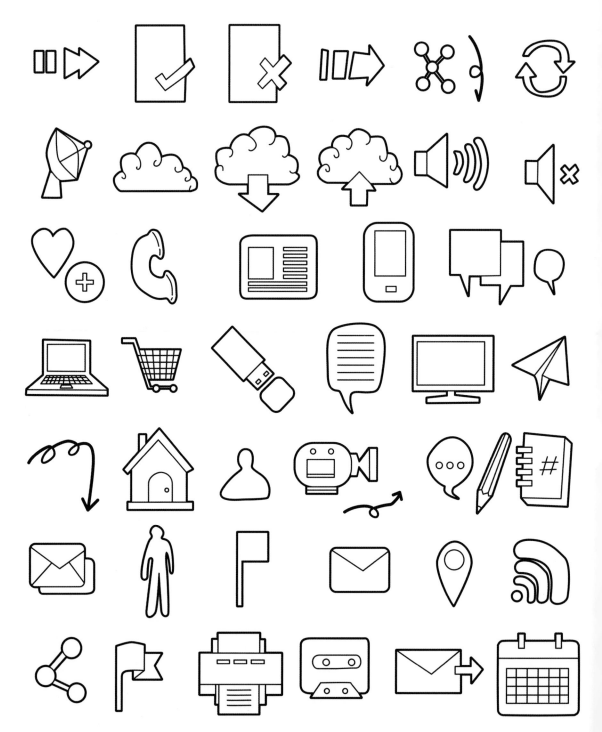

Cha-Ching!

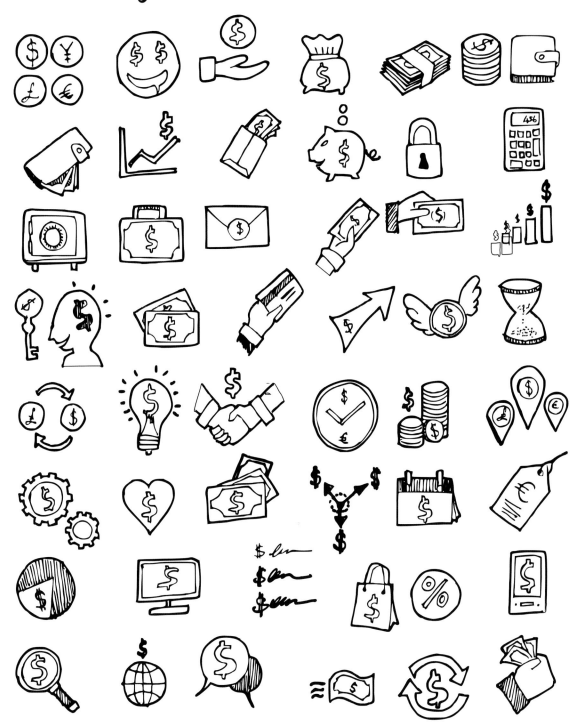

Brain Food

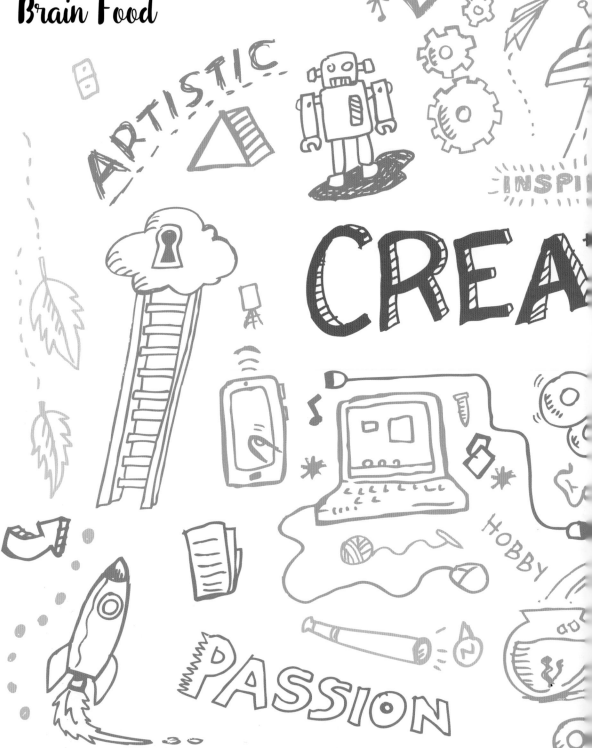

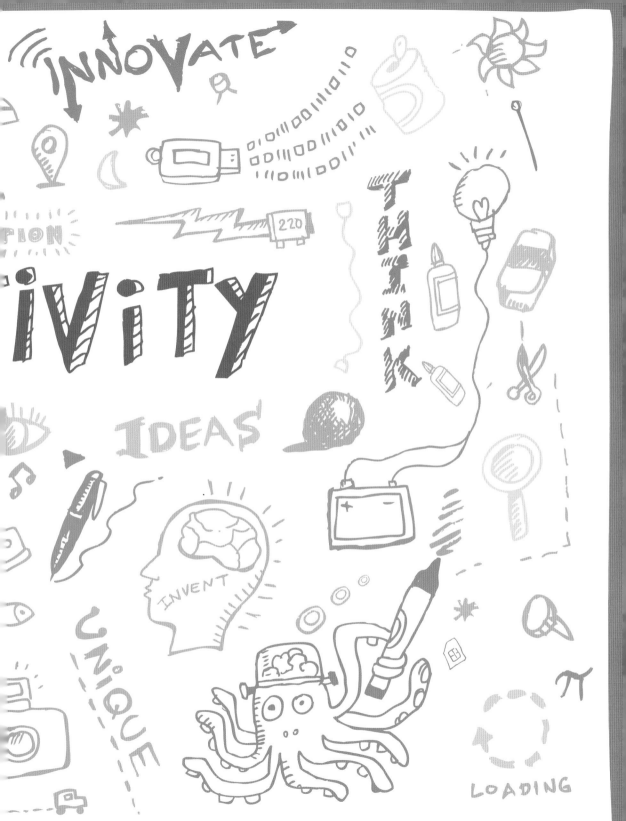

Seasons & Holidays

Doodling seasonal and holiday-themed illustrations are perfect for just about any craft. Consider creating your own wrapping paper using some of the holiday doodles on pages 98 and 100. Adding this personal touch to the gifts you give just might be the perfect way to show others how much you care.

Tempestuous Weather

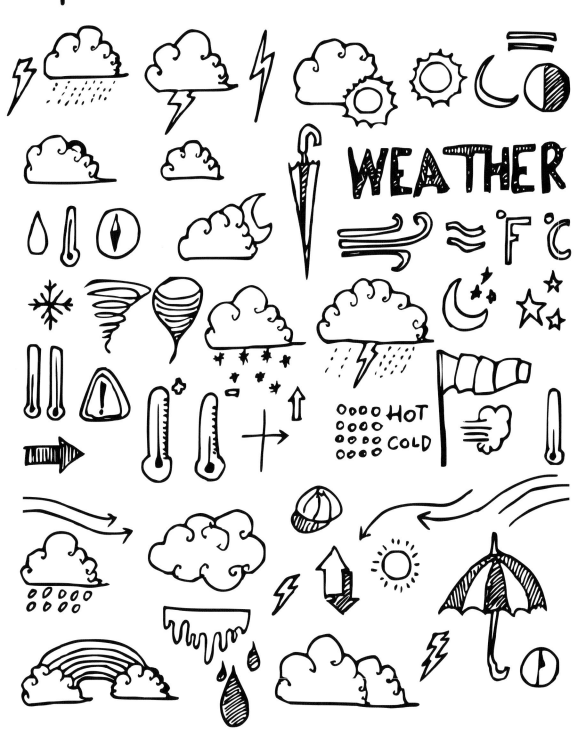

Spring & Easter

Happy spring!

Joyful Springtime

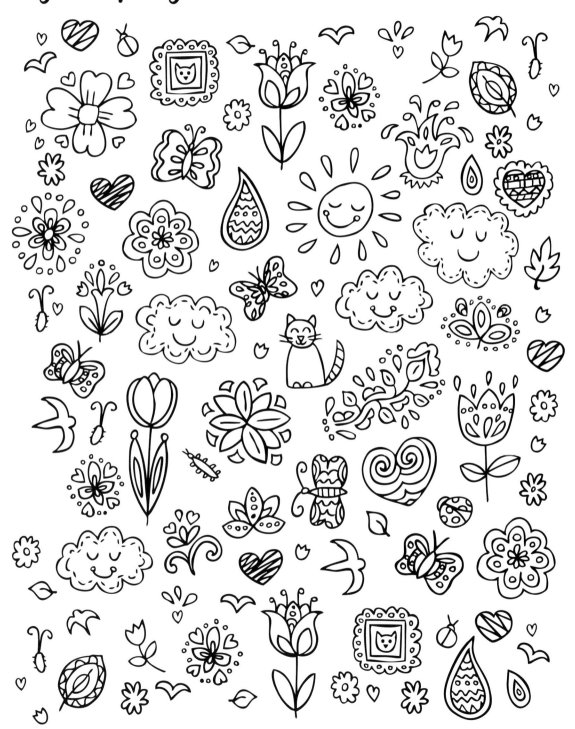

Hello, Summer

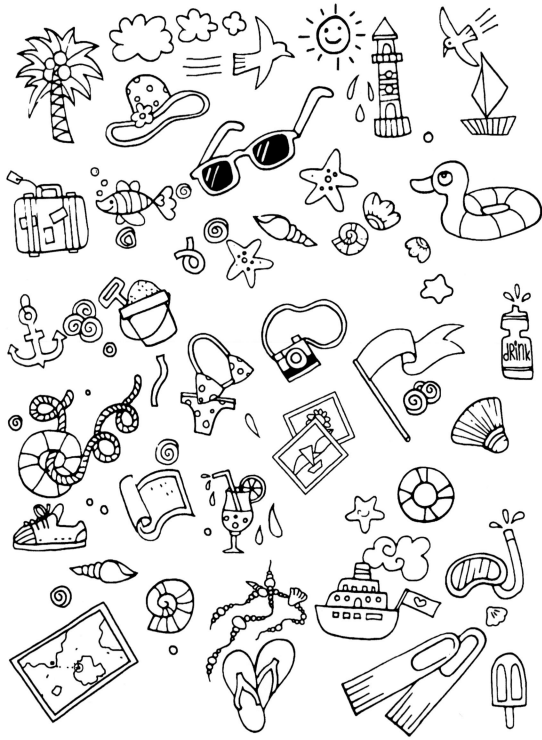

Independence Day

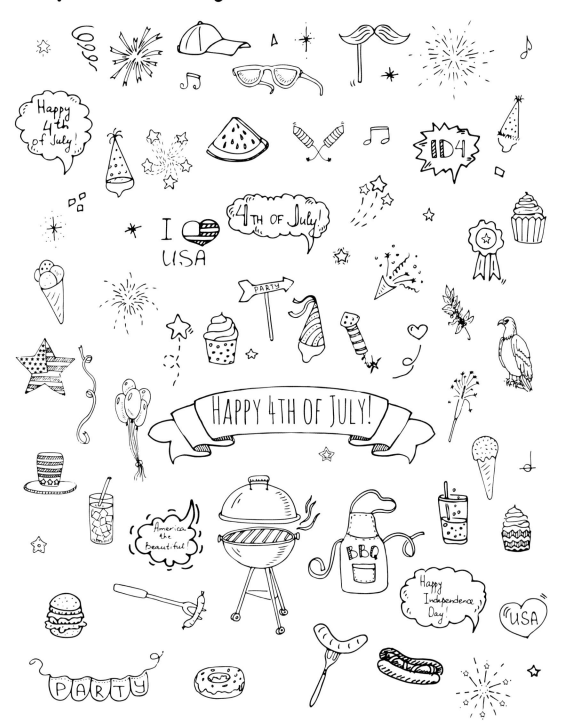

Blustery Autumn

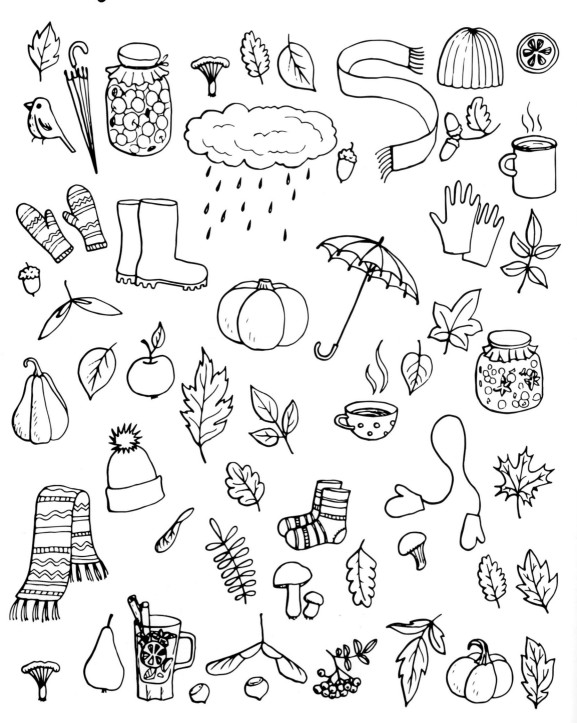

Halloween Fun

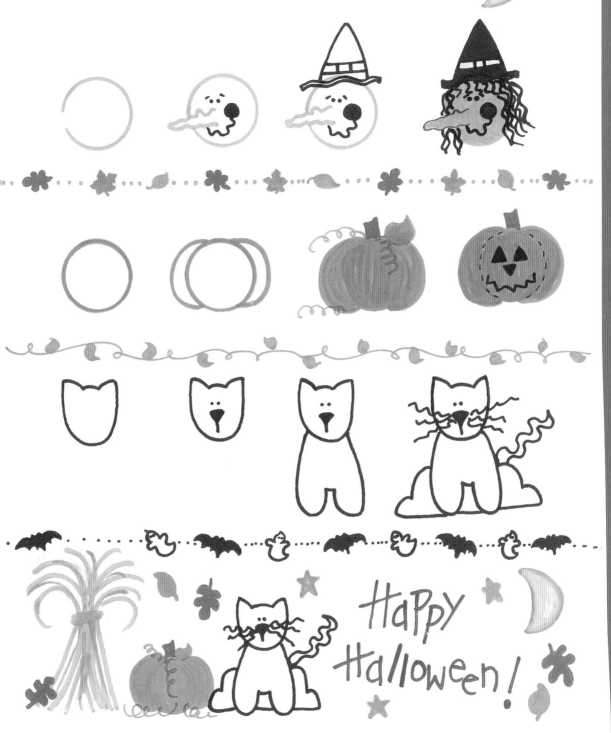

Spooky Halloween

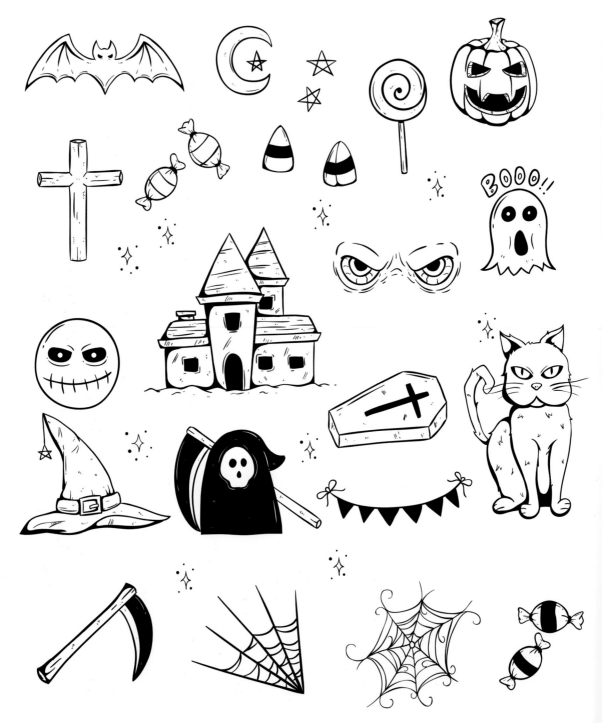

Turkey Day

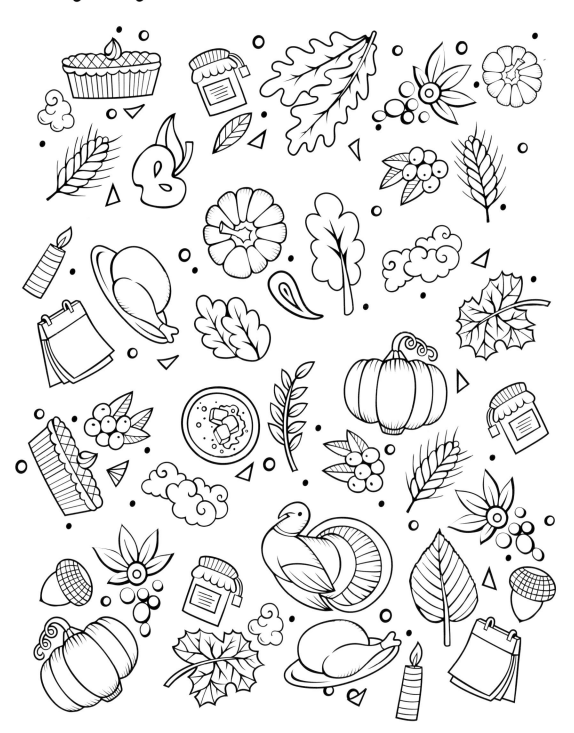

Christmas Festivities

Happy Holidays

Frosty Winter

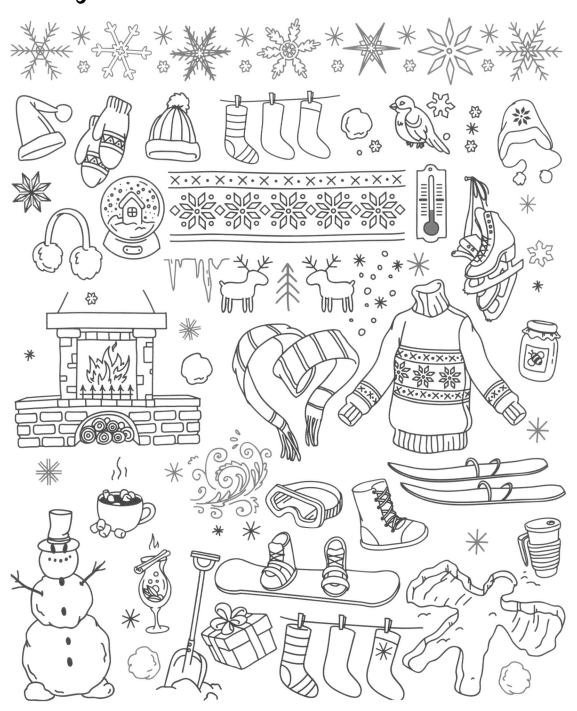

Hanukkah Celebrations

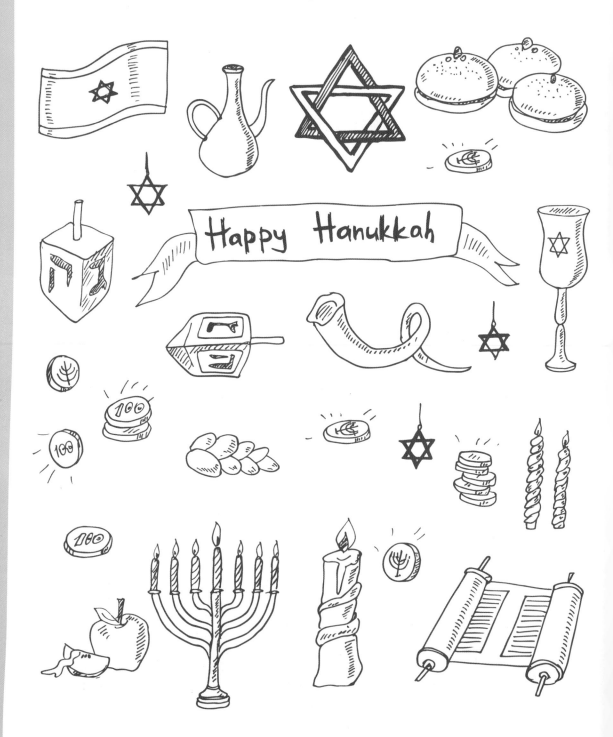

New Year's Eve Merriment

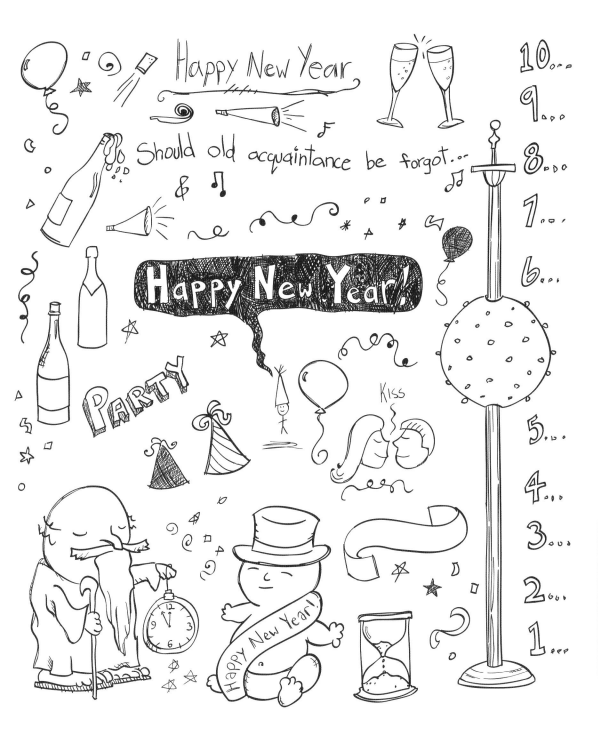

Will You Be My Valentine?

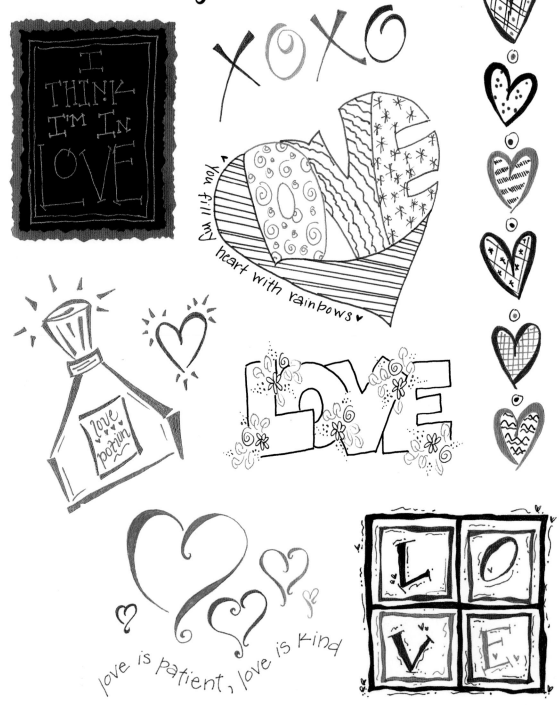

I THINK I'M IN LOVE

XOXO

You fill my heart with rainbows ♥

LOVE

love potion

LOVE

love is patient, love is kind

LOVE

Erin Go Bragh!

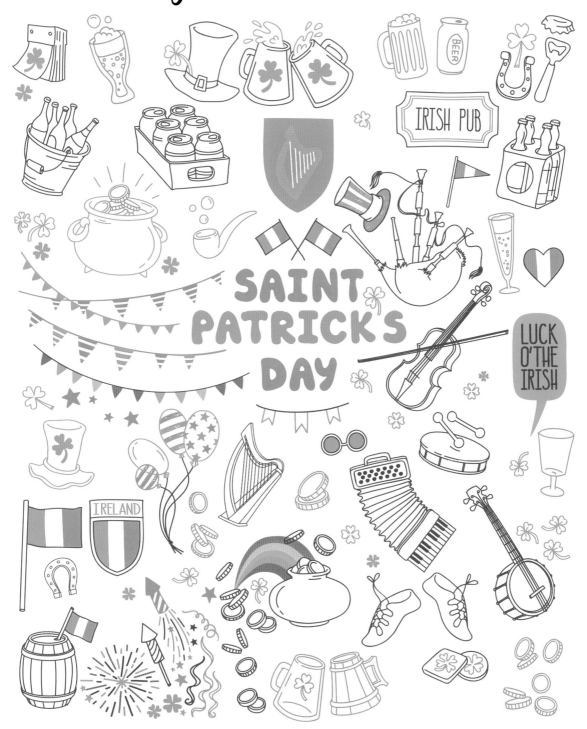

IRISH PUB

SAINT
PATRICK'S
DAY

LUCK
O'THE
IRISH

IRELAND

Birthday Celebrations

Happy Birthday!

Party Time!

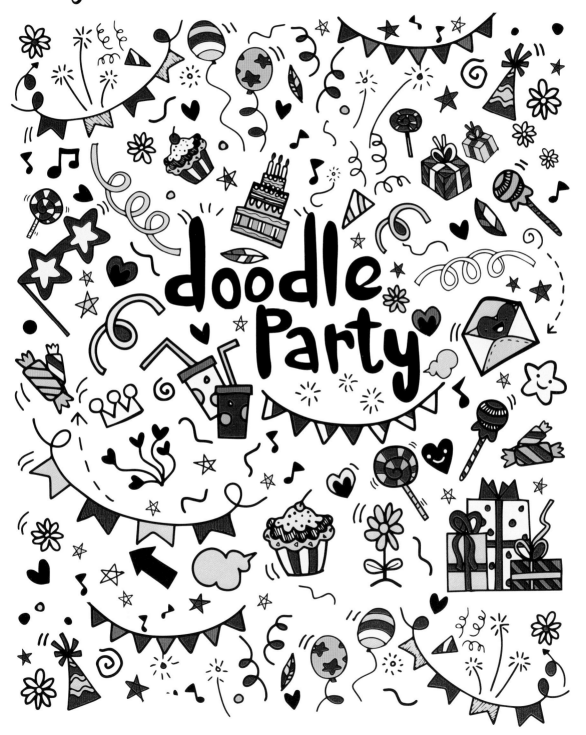

Letters & Numbers

Alphabet and number doodles are quite possibly the most versatile of all doodles and work well with every craft. By changing your font, you'll be able to create wonderful, eye-catching phrases, while also setting the theme at the same time. Practice your name or a favorite phrase using some of the doodles in this section.

Fast Letters & Numbers

Aa Bb Cc Dd Ee
Ff Gg Hh Ii Jj
Kk Ll Mm Nn Oo
Pp Qq Rr Ss Tt Uu
Vv Ww Xx Yy Zz
1 2 3 4 5 6 7 8 9 0

Floral Alphabet

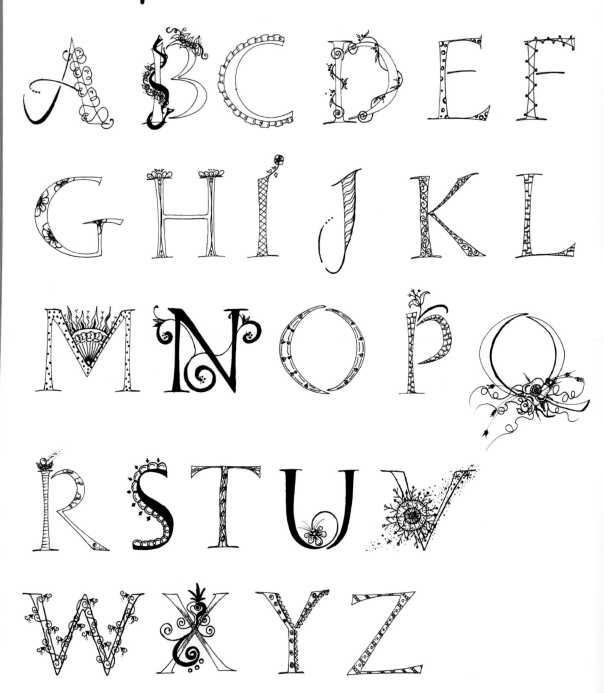

Bubble Letters & Numbers

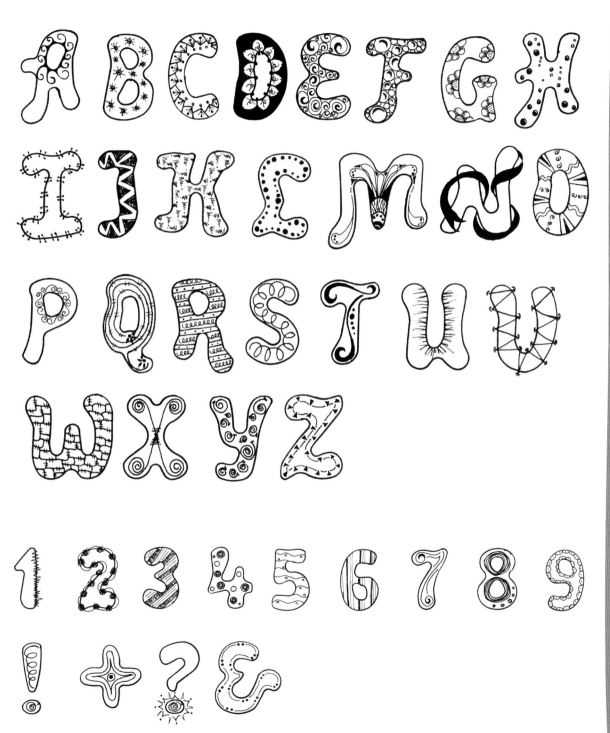

Crafty Alphabet

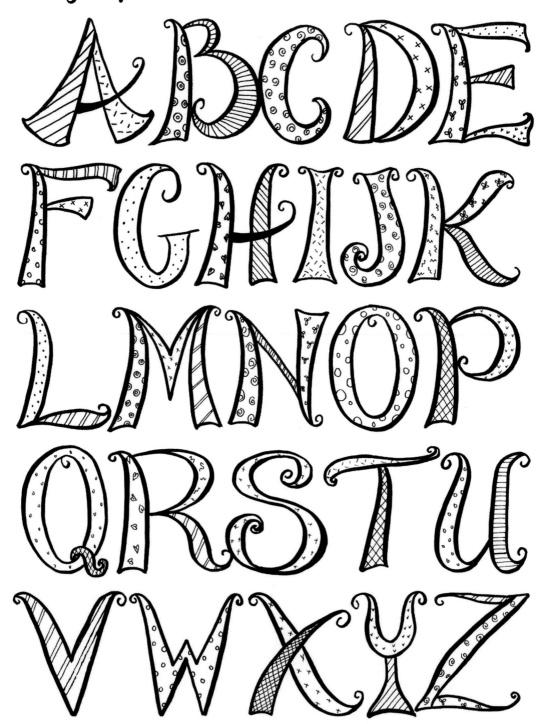

Spiny Letters & Numbers

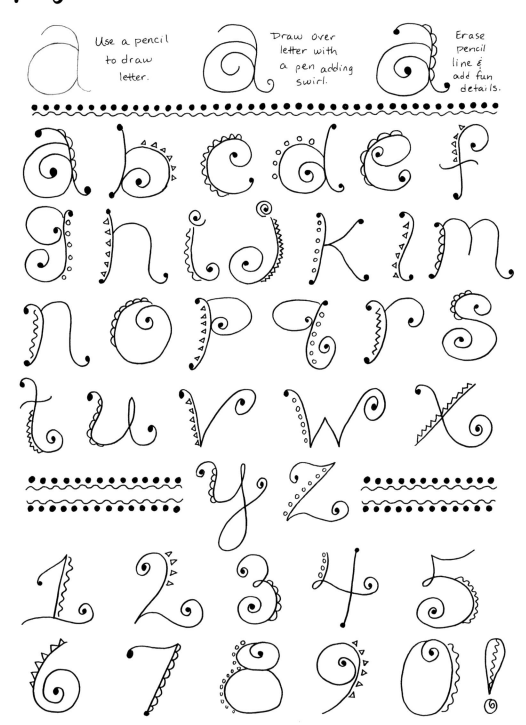

Use a pencil to draw letter.

Draw over letter with a pen adding swirl.

Erase pencil line & add fun details.

Curly Letters & Numbers

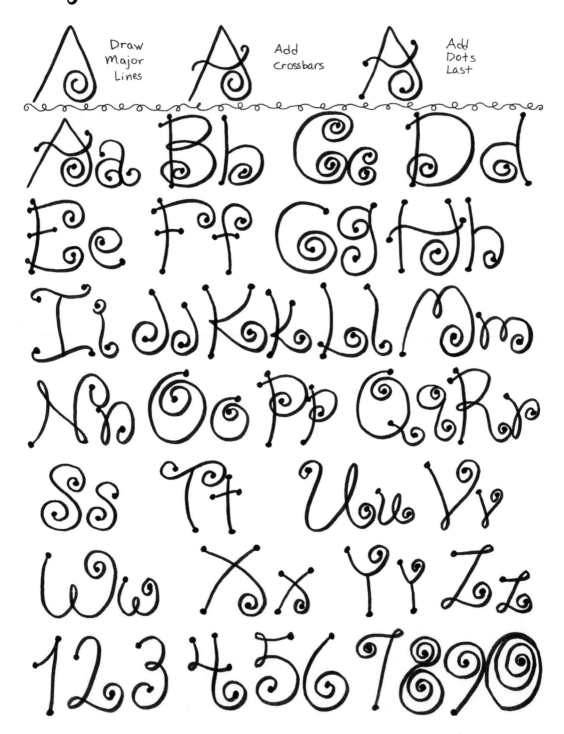

Draw Major Lines

Add Crossbars

Add Dots Last

Aa Bb Cc Dd
Ee Ff Gg Hh
Ii Jj Kk Ll Mm
Nn Oo Pp Qq Rr
Ss Tt Uu Vv
Ww Xx Yy Zz
1 2 3 4 5 6 7 8 9 0

Bold Alphabet

Aa Bb Cc Dd
Ee Ff Gg Hh
Ii Jj Kk Ll Mm
Nn Oo Pp Qq
Rr Ss Tt Uu Vv
Ww Xx Yy Zz

Outlined Letters & Numbers

A — Draw Cursive Letter

A — Add Shadow Line

C — Add Dots

A B C D E F
G H I J K L
M N O P Q R
S T U V W X
Y Z 1 2 3 4 5 6 7 8 9

Dot Design Alphabet

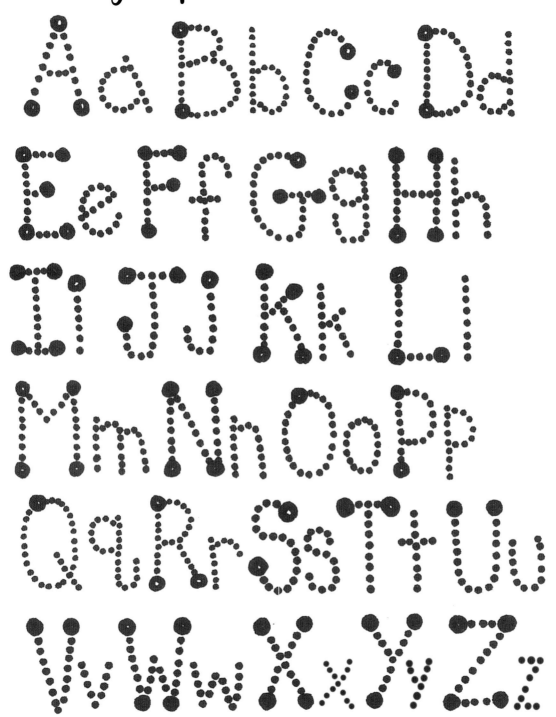

Artsy Alphabets

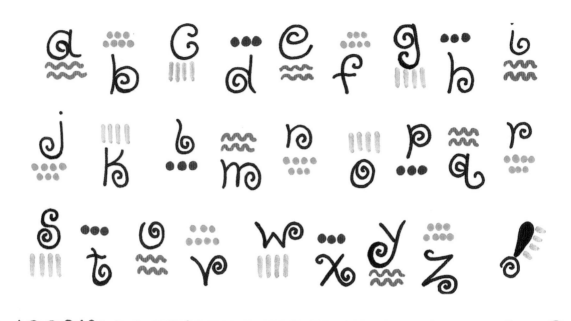

Simple Alphabets

Aa Bb Cc Dd Ee Ff Gg Hh
Ii Jj Kk Ll Mm Nn Oo Pp
Qq Rr Ss Tt Uu Vv Ww Xx Yy Zz

Aa Bb Cc Dd Ee Ff Gg Hh
Ii Jj Kk Ll Mm Nn Oo Pp
Qq Rr Ss Tt Uu Vv Ww Xx Yy Zz

Forget-Me-Not Letters & Numbers

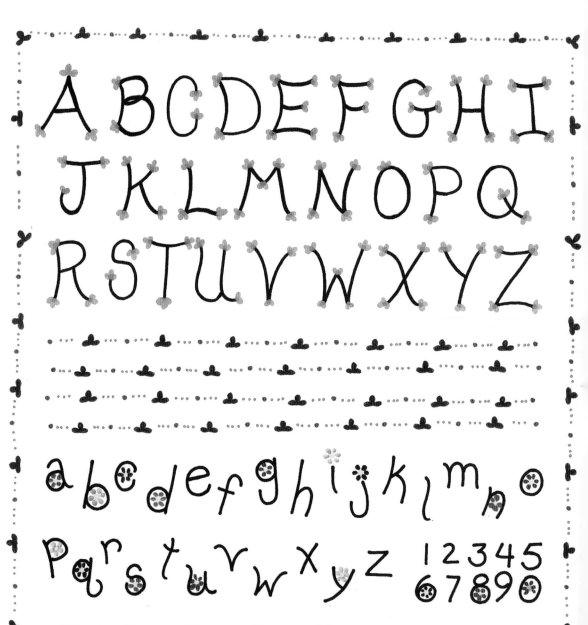

A B C D E F G H I
J K L M N O P Q
R S T U V W X Y Z

a b c d e f g h i j k l m n o
p q r s t u v w x y z 1 2 3 4 5
6 7 8 9 0

Cutesy Alphabet

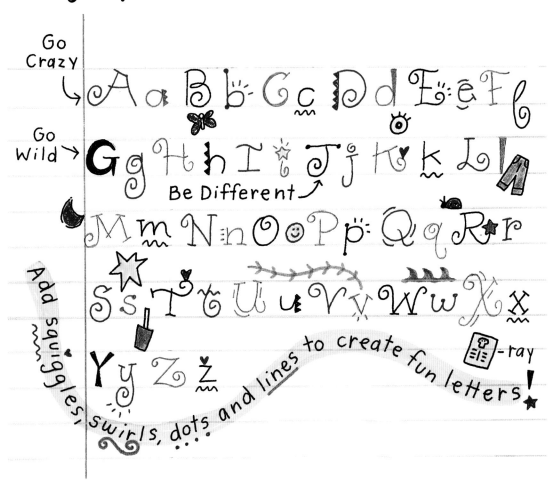

Go Crazy

Go Wild →

Be Different →

Add squiggles, swirls, dots and lines to create fun letters!

TIP

When doodling letters and numbers, it's a good idea to start out using lined paper like you did when you first learned how to write. Once you get the feel and style of your doodle alphabets, you'll be able to use them anywhere with confidence.

Stacked Letters & Numbers

Aa Bb Cc Dd Ee

Ff Gg Hh Ii Jj

Kk Ll Mm Nn Oo

Pp Qq Rr Ss Tt Uu

Vv Ww Xx Yy Zz

1 2 3 4 5 6 7 8 9 0

Dreamy Alphabet

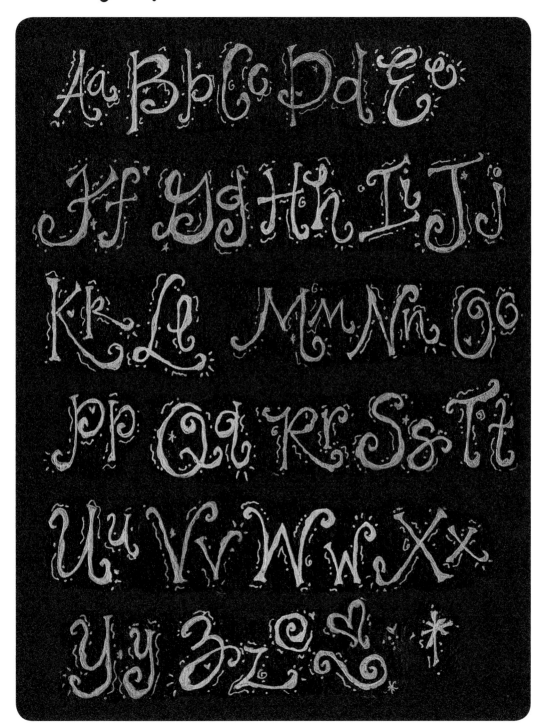

Block Letters & Numbers

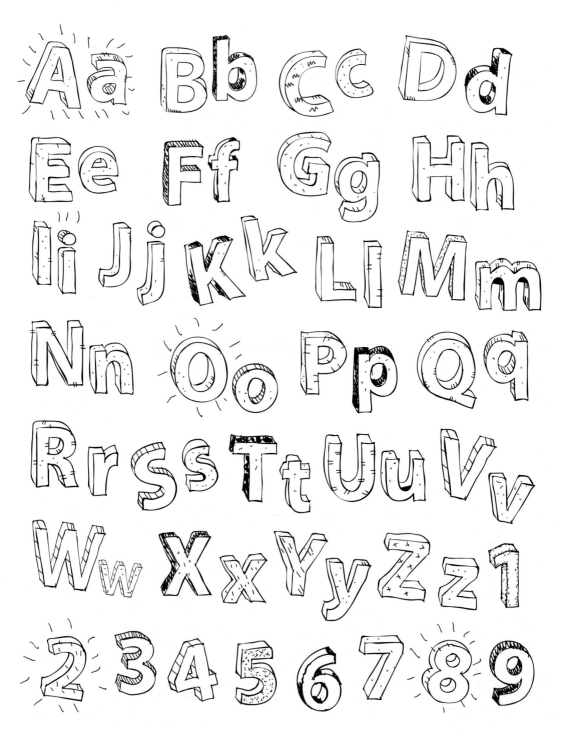

Ampersands & Catchwords

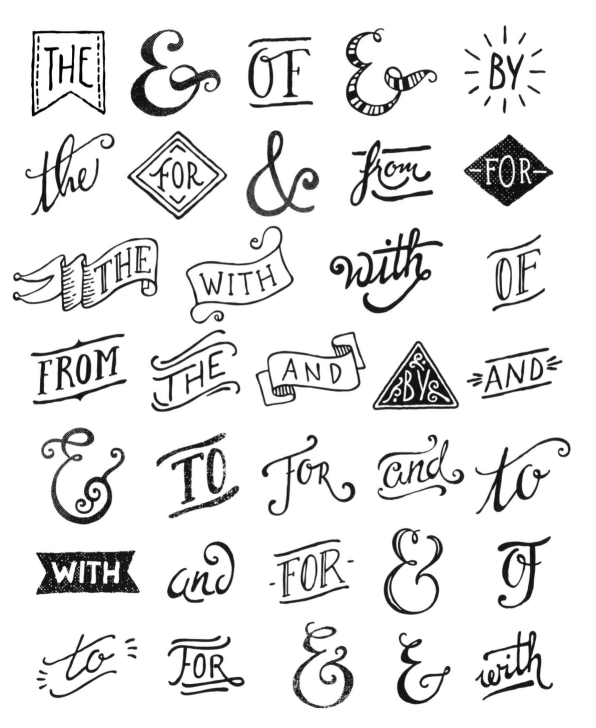

Borders & Frames

The fun thing about borders and frames is that you can transform any image or bit of text into an art piece. They're so customizable that you can add them to any craft you're working on. They're great to use around a picture on your scrapbook page or around the edge of your journal entry. Adding pops of color here and there will also really liven up whatever you're using them on.

Romantic Frames

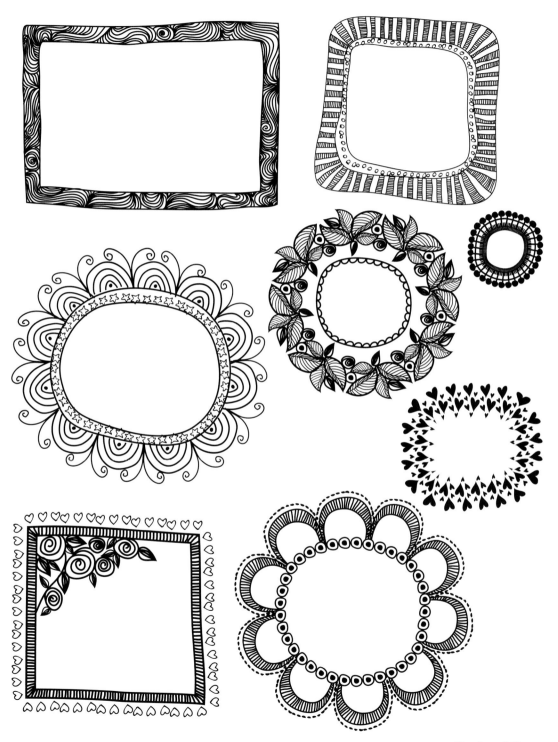

Accented Borders

Dotted Borders

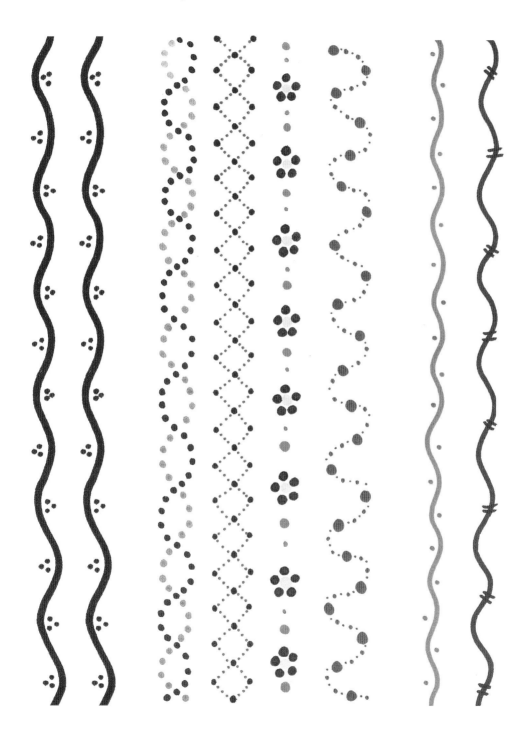

Multicolored Borders

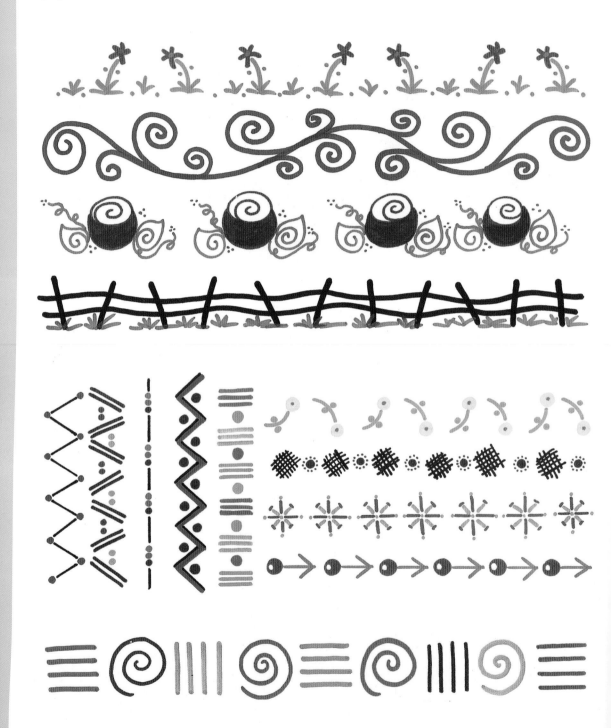

Wildlife Borders

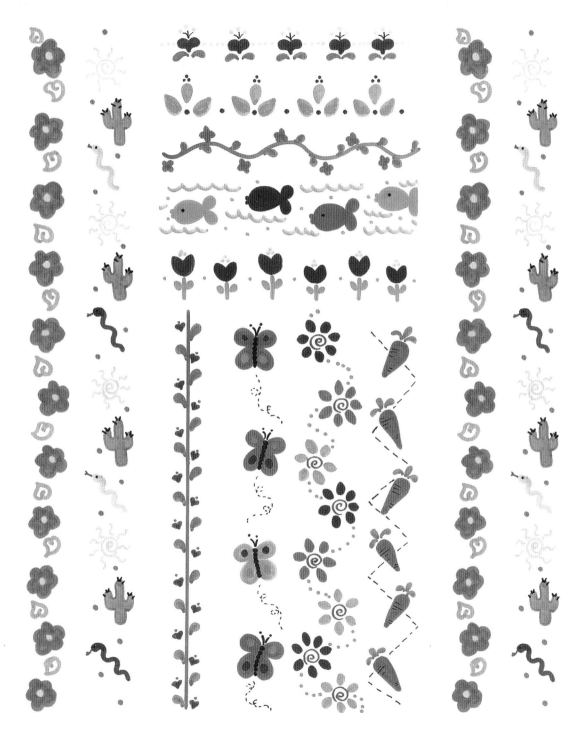

Gel Pen Borders

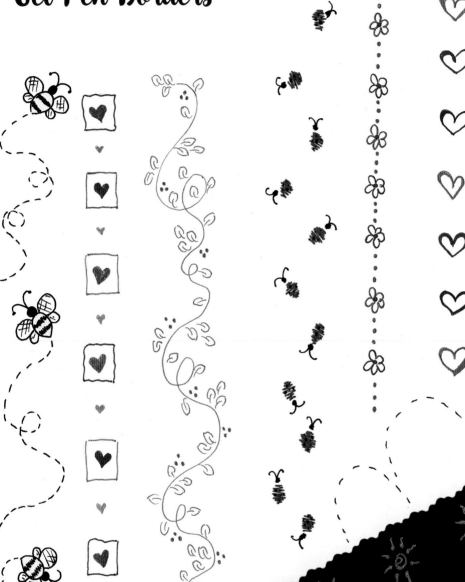

Borders Galore

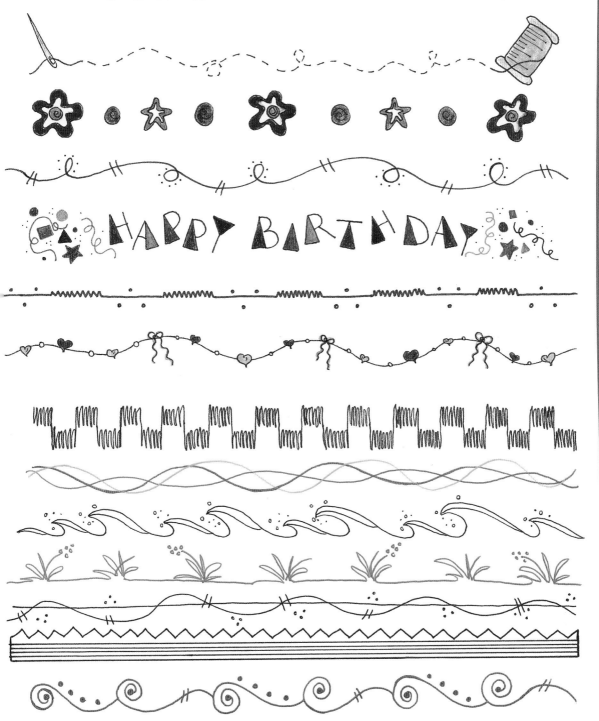

HAPPY BARTHDAY

Bright Borders

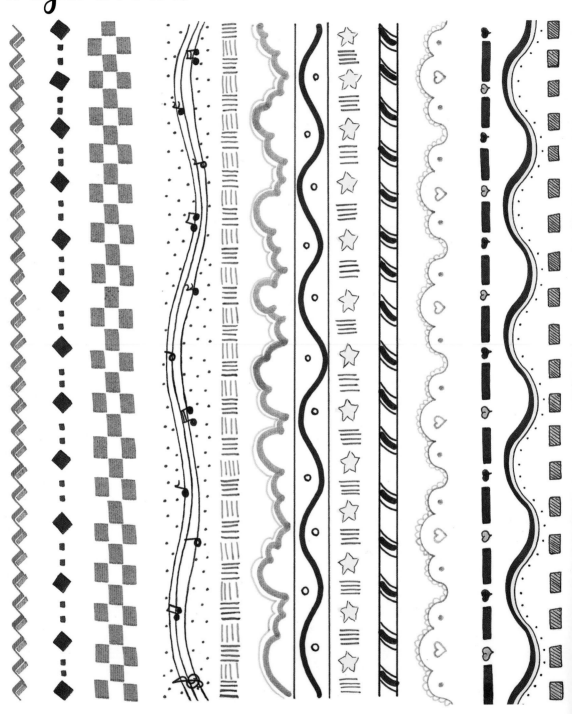

Cheerful Borders

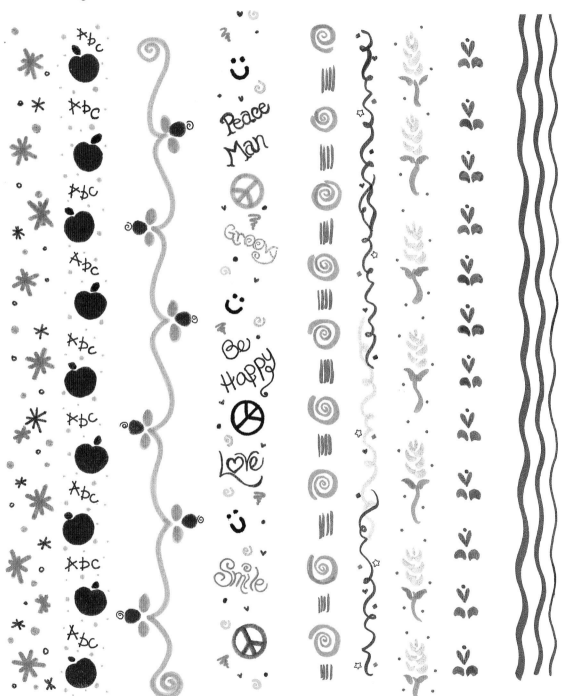

Leafy Borders

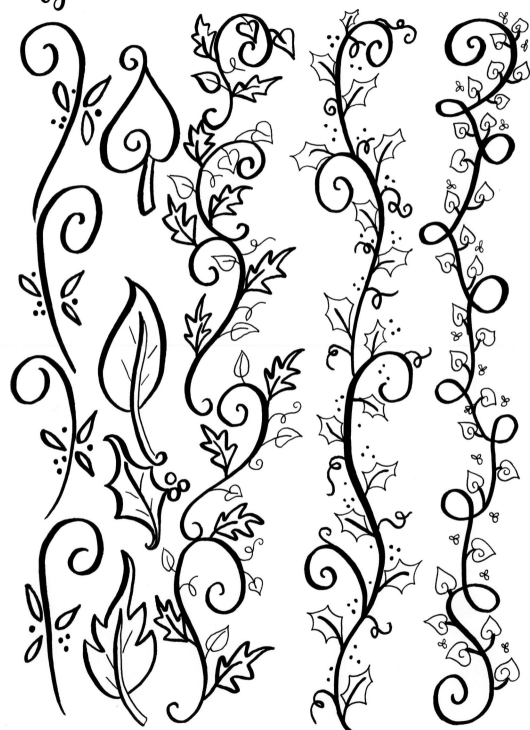

Freehand Frames

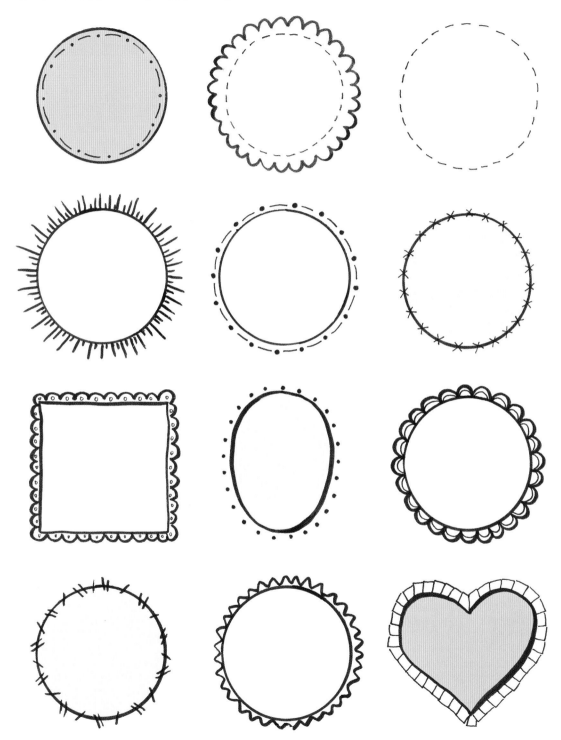

Thin Frames

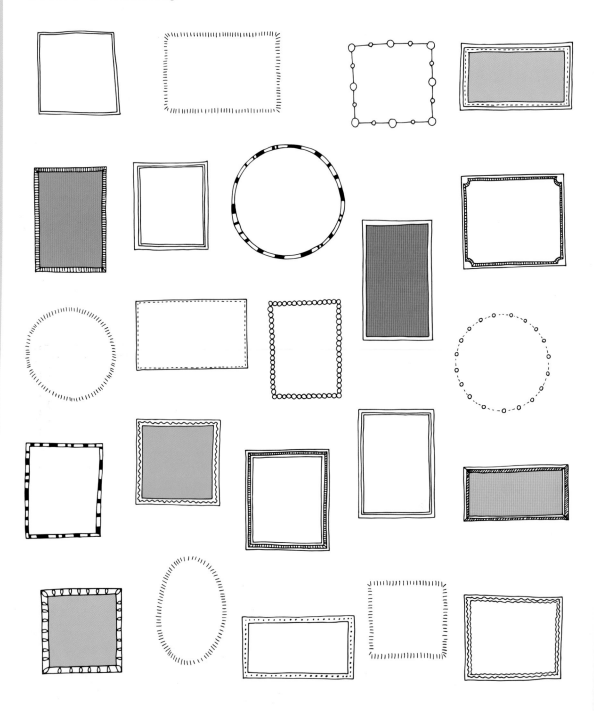

Elaborate Frames

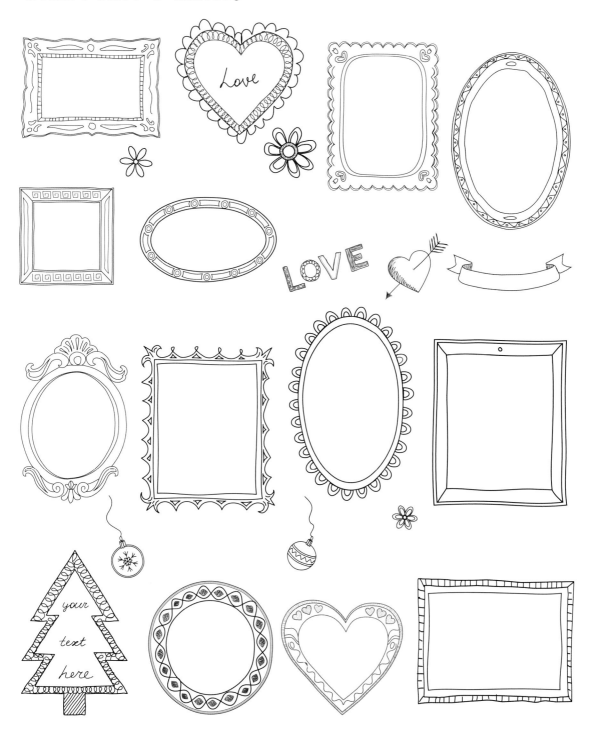

Coiled Frames

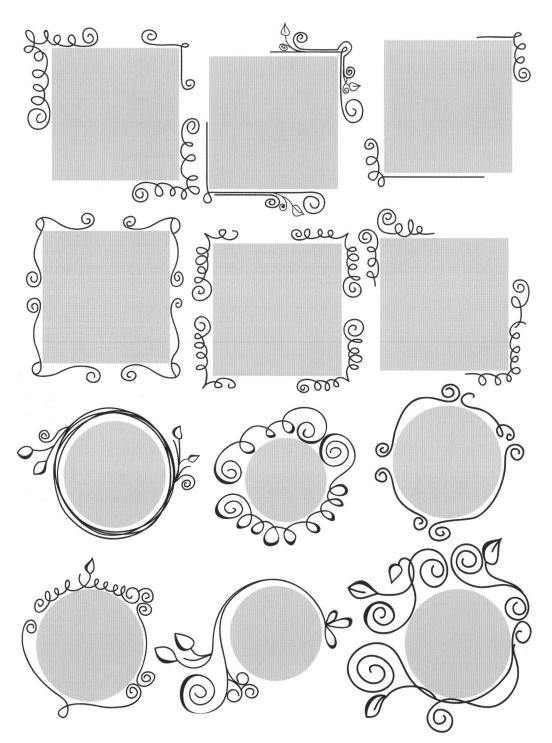

Scrolling Banners

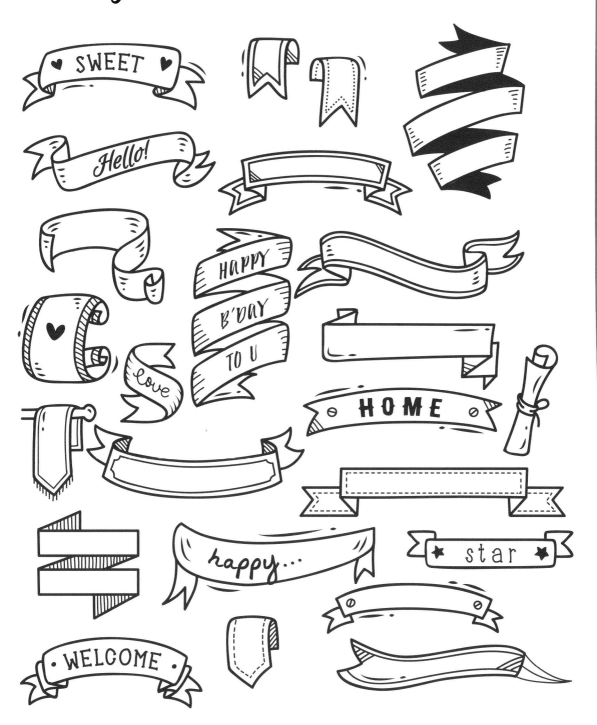

SWEET

Hello!

HAPPY
B'DAY
TO U

love

HOME

happy...

star

WELCOME

Happy Thought Bubbles

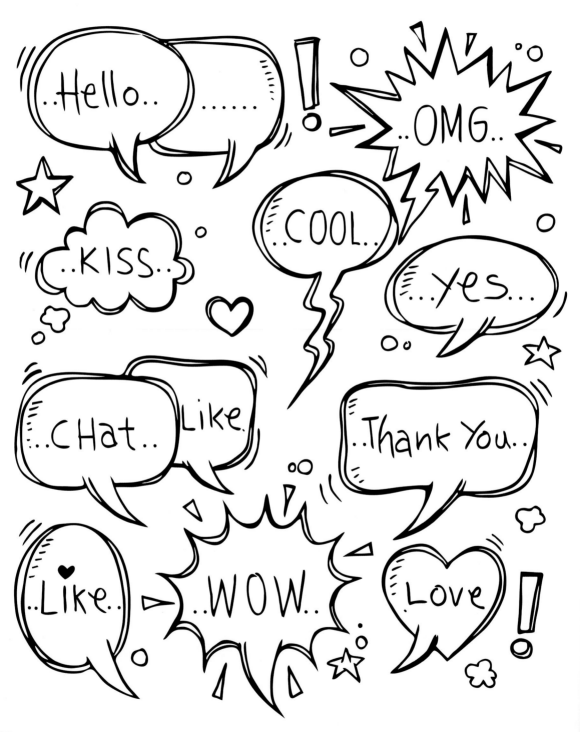

3D Thought Bubbles

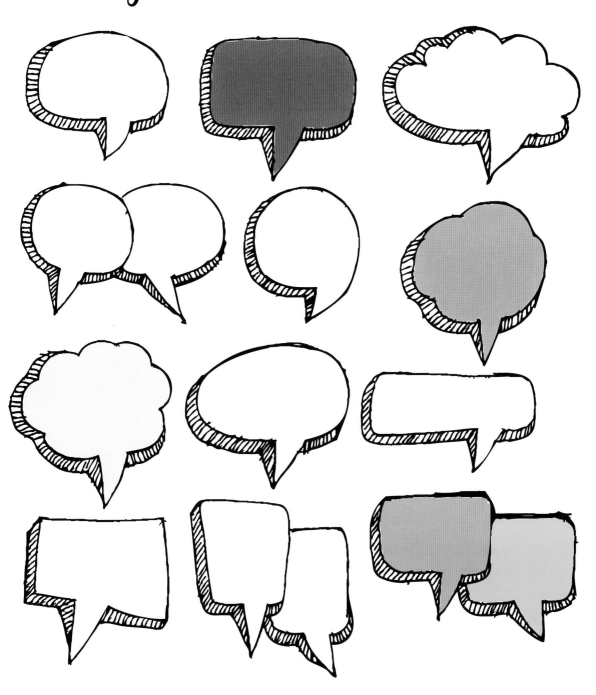

Word Art

The doodles in this section are reminiscent of your school days, where you would sit in class and draw fun bubble words as you pretended to listen. Nowadays, you can still do the same doodles, but use it in a more constructive manner. While there are still some exciting throwback illustrations in this section, you may find the holiday and celebration-themed word art on page 143 particularly useful when crafting or journaling.

Holidays & Celebrations

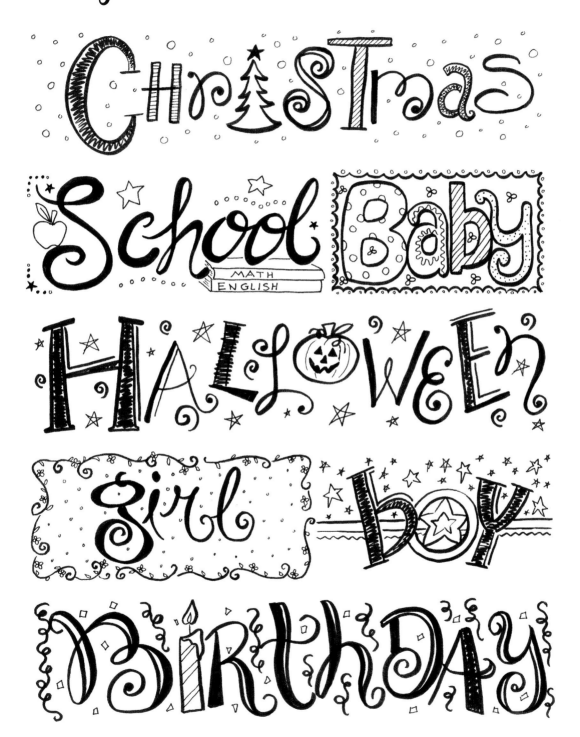

School Day Doodles

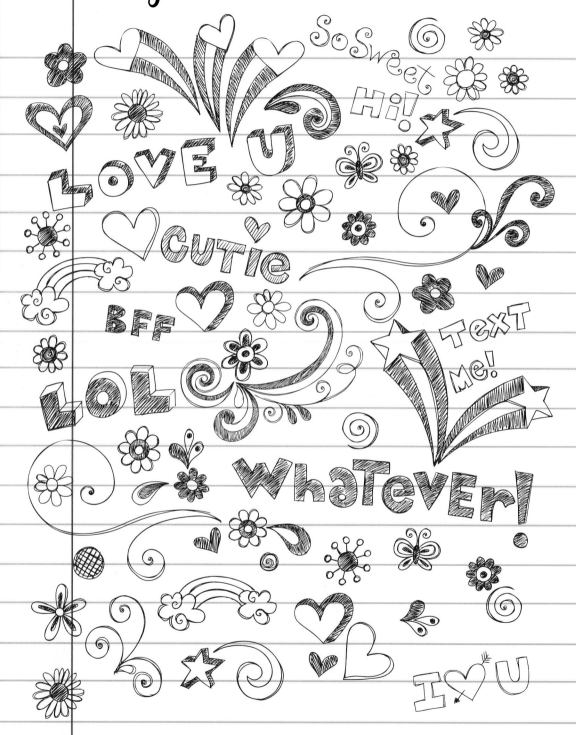

Red are the roses, Green are the hedges, I hope you

Hi Hi Hi

make letters out of lightning bolts, bones or bugs

Try some WAY COOL sayings!

no way, way!

Gotta Bail!

Don't be a foolio→ you need to go to schoolio!

CHILLIN'

Sweet

girlfriend

Dude

WAY COOL

What's up!

I'm so Jazzed

don't mind me writing on the edges.

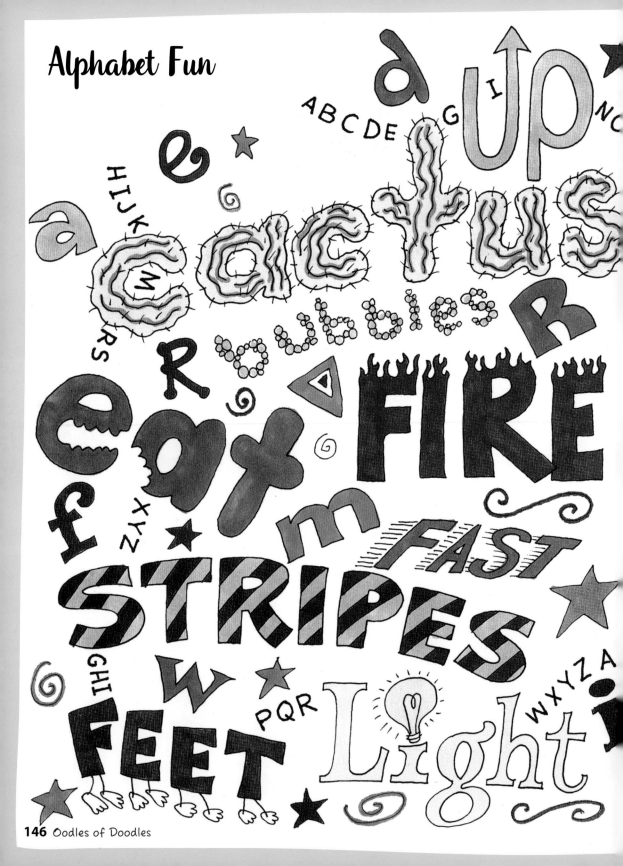

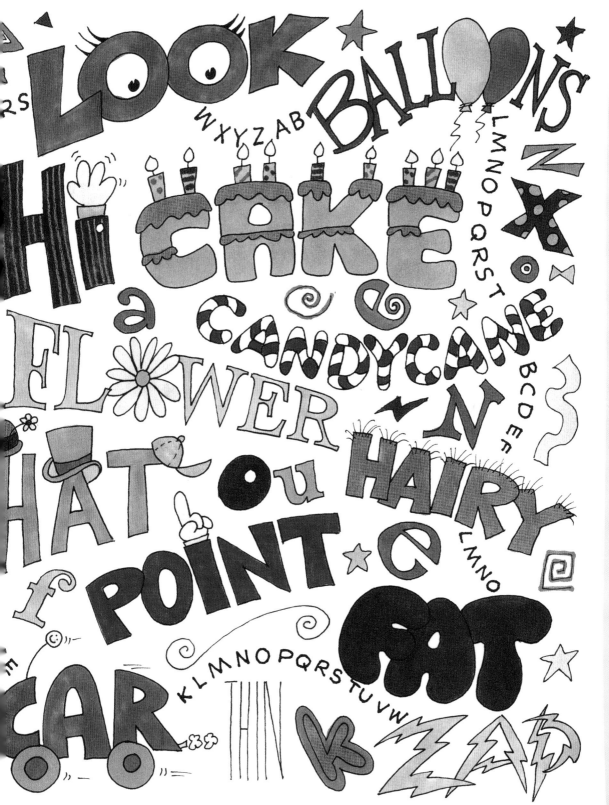

Lettered Animals

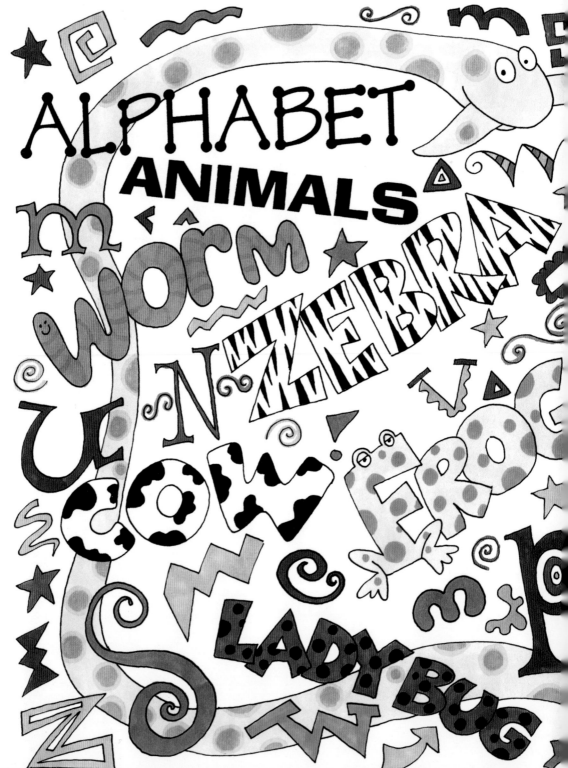

ALPHABET ANIMALS

WORM

ZEBRA

COW

FROG

LADYBUG

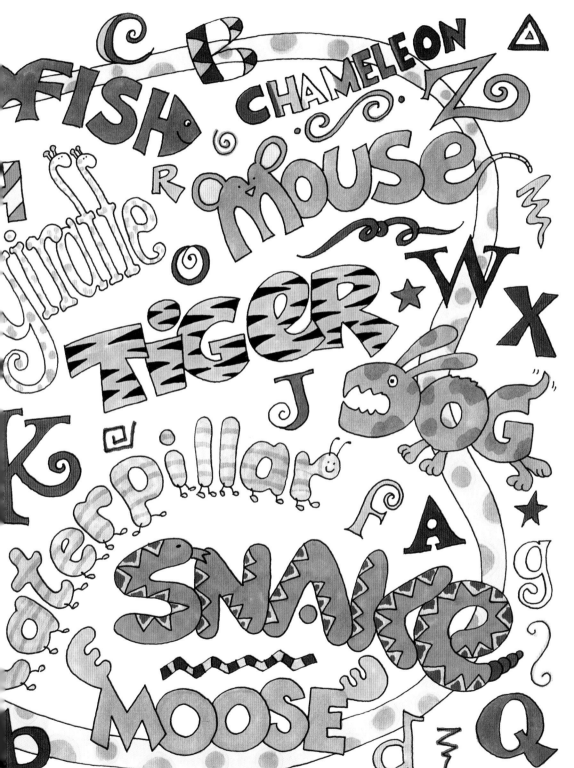

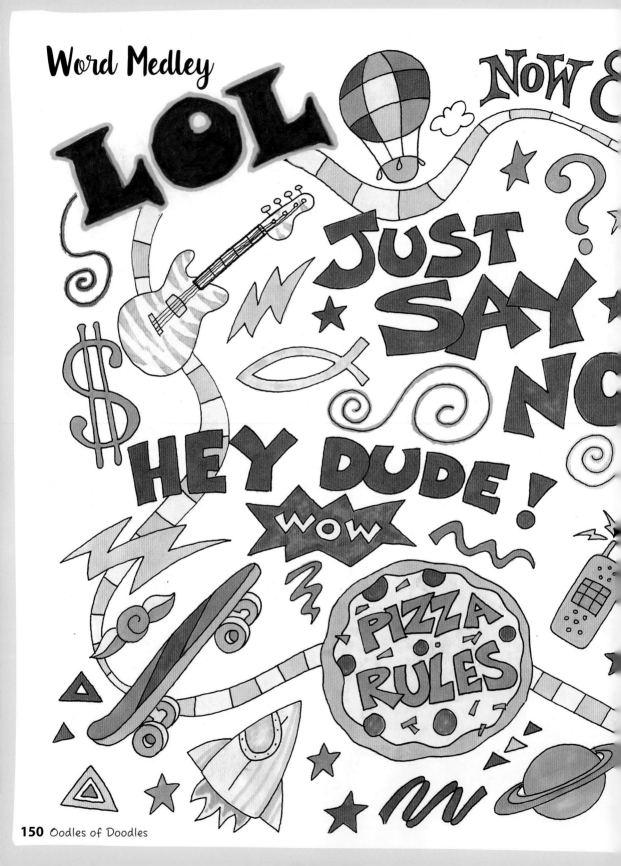

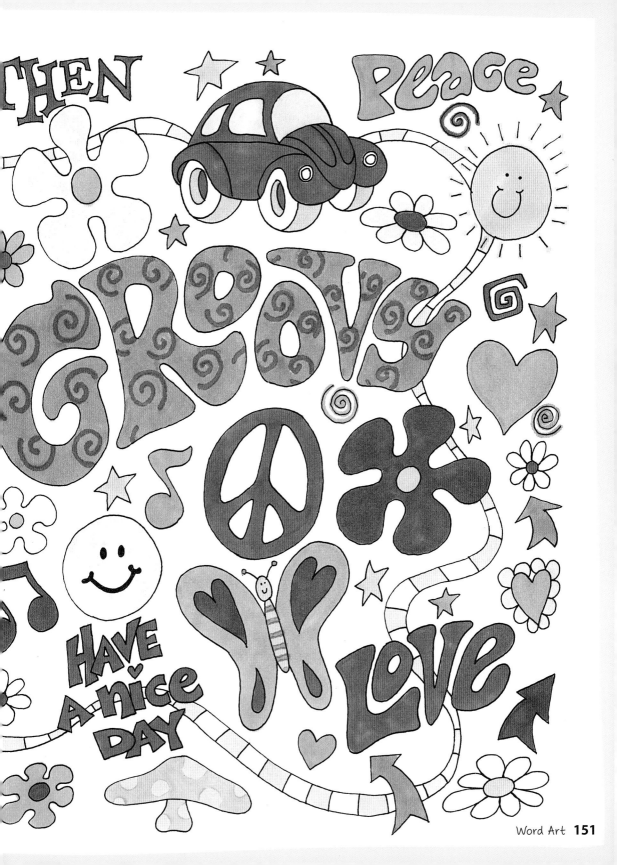

PROJECTS

What's more fun than taking the doodles you've been using in this book and applying them to some imaginative projects? The following section has some ideas to get you started. Not only are they easy to do, they're also really fun and cute. You can always take these basic projects and create your own theme to personalize them. To take it a little further, use the projects in this book as inspiration for your own creations. For example, instead of drawing planets for your space-themed mobile (page 158), you could draw birds, planes, butterflies, flowers, etc. The possibilities are endless!

These projects were primarily done with gel pens, but you can use your favorite doodle pen if you prefer. The same applies to the color schemes. Make your designs colorful or make them monochromic . . . whatever suits your fancy! The cootie catchers (pages 154–156) would especially benefit from your favorite designs. Don't forget to add the little details, like borders or frames, to make them especially pretty.

Basic Cootie Catcher

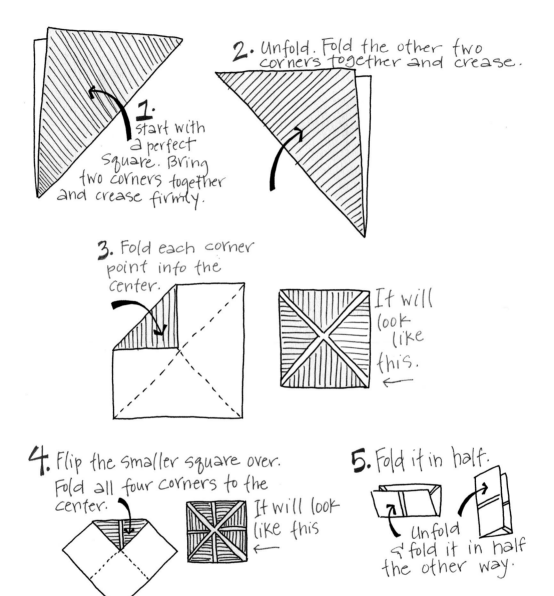

1. Start with a perfect square. Bring two corners together and crease firmly.

2. Unfold. Fold the other two corners together and crease.

3. Fold each corner point into the center.

It will look like this.

4. Flip the smaller square over. Fold all four corners to the center.

It will look like this

5. Fold it in half.

Unfold & fold it in half the other way.

You may know these as Wisdom Makers, Fortune Tellers, Treasure Keepers, or Cootie Catchers. No matter what you call them, they are lots of fun! With gel pens, you can make one out of light or dark paper. Use just about any theme from this book, or come up with your own ideas.

Floral Cootie Catcher

how to play:

1. Your player chooses one of the top four squares.
2. If it is a number, open and close the cootie catcher the right number of times. If it is a picture or word, open and close it the correct number of letters (spelling out the word).
3. When you are done counting, the player chooses an inside panel.
4. Repeat step 2.
5. The player chooses another inside panel.
6. Flip up the panel and read the fortune!

Here's a cootie catcher design to get you started. ↓ You can trace the design or copy it on a photocopier. Then, experiment with your own designs. Have fun!

friendship

intrigue

adventure

happiness

You'll kiss a handsome guy-and he'll turn into a frog.

You'll marry the next guy who talks to you.

a surprise invitation is on its way.

Your loathed enemy will play a nasty trick on you.

You'll get caught writing notes in class.

The guy you've been watching will smile at you.

Your mom will embarrass you horribly.

A cute stranger will ask for your phone number.

love

excitement

surprise

loyalty

Animals Cootie Catcher

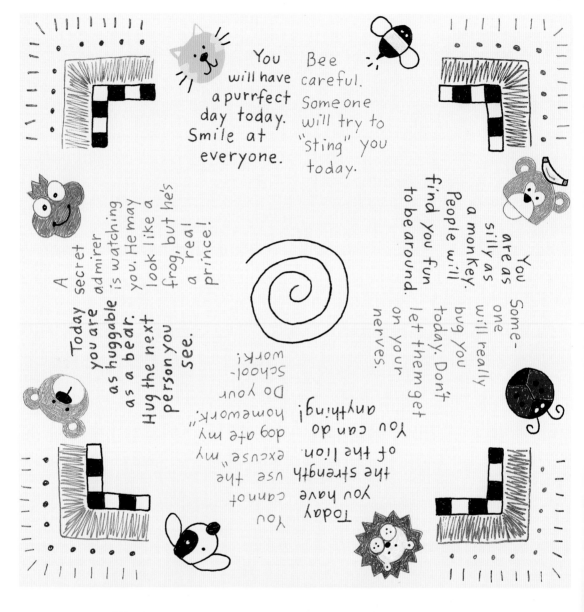

You will have a purrfect day today. Smile at everyone.

Bee careful. Someone will try to "sting" you today.

You may look like a frog, but he's a real prince!

A secret admirer is watching you. He may look like a frog, but he's a real prince!

Today you are as huggable as a bear. Hug the next person you see.

You are as silly as a monkey. People will really bug you today. Don't let them get on your nerves.

Someone will find you fun to be around.

Do your homework! "My dog ate my homework!" School-work!

You cannot use the excuse "my dog ate my homework!"

Today you have the strength of the lion. You can do anything!

Other Projects

Color and cut out shapes from Bristol board to hang from the top of your door.

Doodle on paper and glue around a clean soup can to make a pencil holder. ♥ Do the same for decorative pencils.

make a room sign!

ENTER AT YOUR OWN RISK

YIKES!

Doodle on your lunch bag.

start

Doodle a Treasure map, leading a friend to a hidden note. x x x

BOOKMARKS!

Only Cool Chicks

NO BOYS!

Go For It!

Flower Power

Scribble out some quick stand-up cards for friends.

Tip

The best thing about doodling is that with the appropriate pens or markers, you can make any surface more lively and colorful. It's an effective boredom-killer as well as an excellent way to practice drawing on a daily basis.

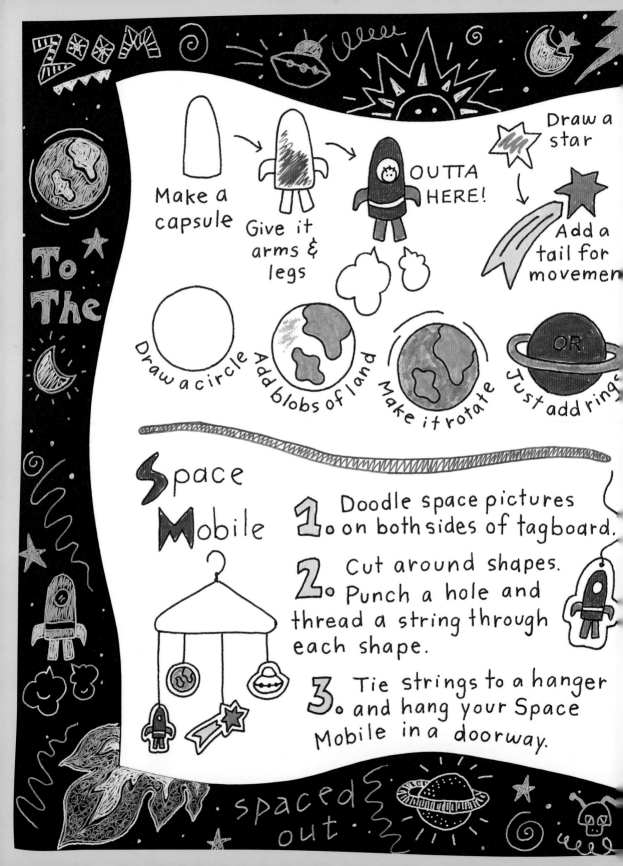

ZOOM

To The

Make a capsule

Give it arms & legs

OUTTA HERE!

Draw a star

Add a tail for movement

Draw a circle

Add blobs of land

Make it rotate

OR

Just add rings

Space Mobile

1. Doodle space pictures on both sides of tagboard.

2. Cut around shapes. Punch a hole and thread a string through each shape.

3. Tie strings to a hanger and hang your Space Mobile in a doorway.

spaced out

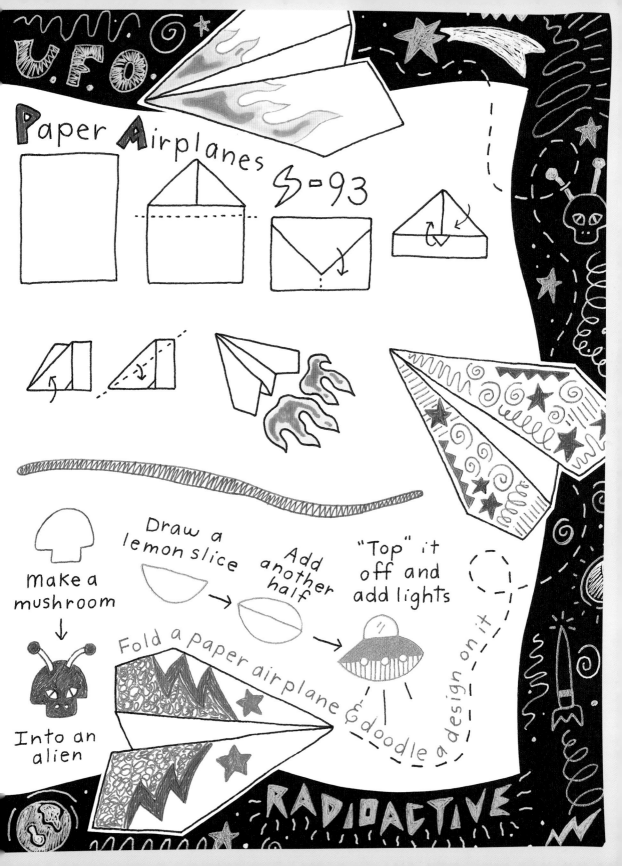

U.F.O.

Paper Airplanes

$S = 93$

make a mushroom

↓

Into an alien

Draw a lemon slice

Add another half

"Top" it off and add lights

Fold a paper airplane & doodle a design on it

RADIOACTIVE

About the Contributors

SUZANNE McNEILL

 Suzanne received the Lifetime Achievement Award from the Craft & Hobby Association and has been noted as one of the arts and craft industry's top trendsetters. Dedicated to hands-on creativity, she is constantly testing, experimenting, and inventing something new and fun. Suzanne is the author of more than 230 craft and hobby books, and her creative vision has placed her books on the top of the trends for over 25 years.

ANDREA GIBSON

 Andrea loves making things with her hands and sharing her creativity with others. The fun doodles she created for this book were constructed to inspire creativity. She enjoys designing layouts, cards, and jewelry.

DONNA GOSS

 Donna is an innovative and energetic multimedia artist. She has created stamp art since 1992. Currently, she enjoys planning arts and crafts events as well as teaching classes. Her talent repertoire includes soldering, collage, scrapbooking, beading, jewelry, and metalwork.

TONYA BATES

 Tonya spends her time creating crafts and fine arts. She enjoys papercrafting, painting, sculpting, ceramics, drawing, decorating, and playing the piano.

EMILY ADAMS

 Emily is a jack-of-all-trades. From her website, *www.EmilyAdamsOnFire.com*, she offers services on graphics and logos, web design, and social media content, among other things. Emily also has her own line of products that feature her graphic designs, such as art prints, mugs, and T-shirts.

JAIME ECHT

 Jaime is the founder and creator of The Crafter's Workshop, a company that started as a small paper arts shop, but now has expanded to distribute templates, stencils, acrylic paint, and much more. You can contact her and see more of her designs at *www.TheCraftersWorkshop.com*.

CYNDI HANSEN

 Cyndi has been crafting her whole life and has tried every craft imaginable. She has worked as a craft designer and as a florist. She loves designing album page ideas and projects that will add flair to memory books. Cyndi also enjoys using hand lettering to personalize projects and gifts to make them even more enjoyable to family and friends.